POLYMER CLAY
CHINESE STYLE

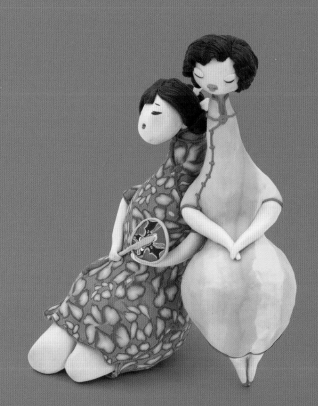

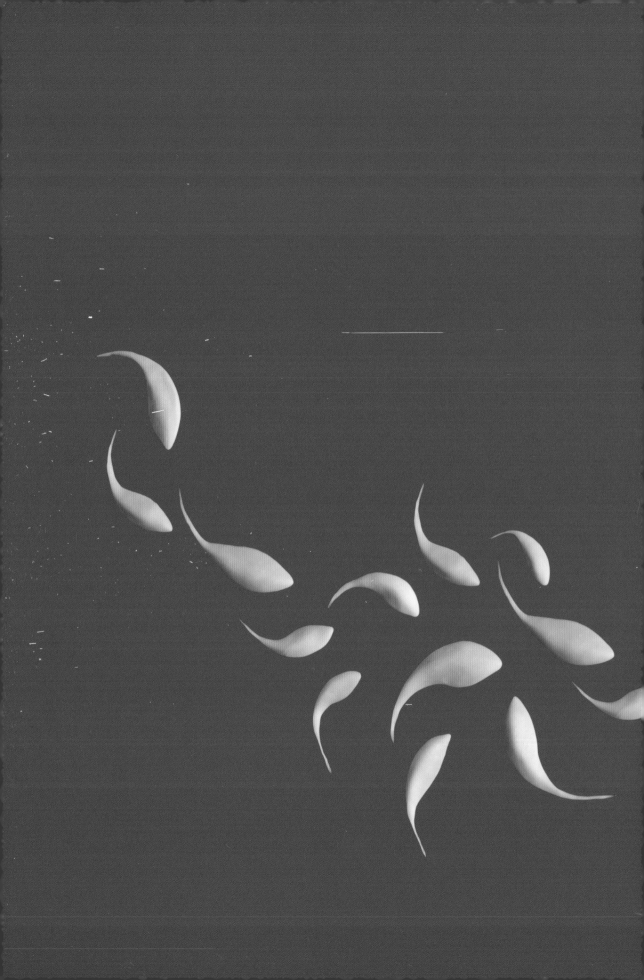

POLYMER CLAY
CHINESE STYLE

Unique Home Decorating Projects
that Bridge Western Crafts and Oriental Arts

By Han Han

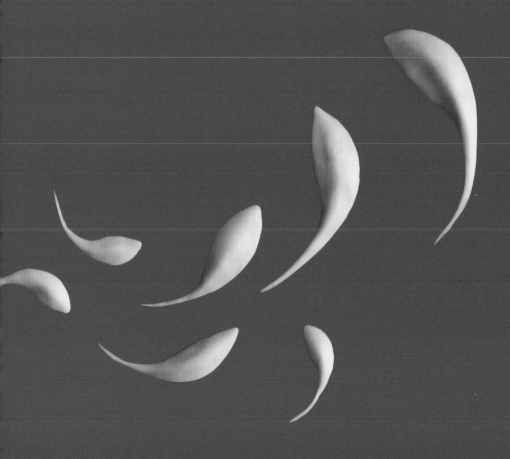

Better Link Press

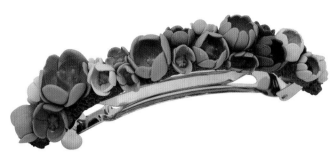

On page 1
The Great Charms of the Traditional Ladies
Designer: Han Han
The traditional ruffled collars and the knot buttons elevate the stunning beauty of the classic ladies. Please refer to the project of the lady on the right on page 102 for the steps.

On pages 2–3
A Shoal of Jade Fish
Designer: Han Han
Please refer to the project on page 34 for the steps.

Right
Green Floral Barrette
Designer: Han Han
The flowers clustered on the barrette in various shades of green, arranging in a form of arch, are half-open, like the shy smiles of the traditional Chinese ladies.

Facing page, top right
Cloth Tiger Polymer Clay Charm
Designer: Yang Wei
The cloth tiger is the traditional folk craft toy. Since ancient times, tiger is believed to have the power to drive out evil spirits. Thus, the cloth tiger is a great gift for newborn to wish it good health.

Facing page, bottom left
The Rabbit God
Designer: Han Han
The Rabbit God is the traditional Chinese auspicious symbol. It is very common to be displayed in the Mid-Autumn Festival to collect more blessings. Does this Rabbit God look bold and brave?

Copyright © 2016 Shanghai Press and Publishing Development Company

All rights reserved. Unauthorized reproduction, in any manner, is prohibited.

This book is edited and designed by the Editorial Committee of *Cultural China* series

Text and Works: Han Han
Carving Works: Li Xinyang

Translation: Kitty Lau

Cover Design: Wang Wei
Interior Design: Li Jing, Hu Bin (Yuan Yinchang Design Studio)

Editor: Wu Yuezhou
Editorial Director: Zhang Yicong

Senior Consultants: Sun Yong, Wu Ying, Yang Xinci
Managing Director and Publisher: Wang Youbu

ISBN: 978-1-60220-022-7

Address any comments about *Polymer Clay Chinese Style* to:

Better Link Press
99 Park Ave
New York, NY 10016
USA

or

Shanghai Press and Publishing Development Company
F 7 Donghu Road, Shanghai, China (200031)
Email: comments_betterlinkpress@hotmail.com

Printed in China by Shenzhen Donnelley Printing Co., Ltd.

1 3 5 7 9 10 8 6 4 2

CONTENTS

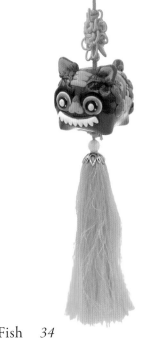

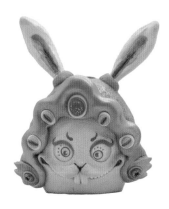

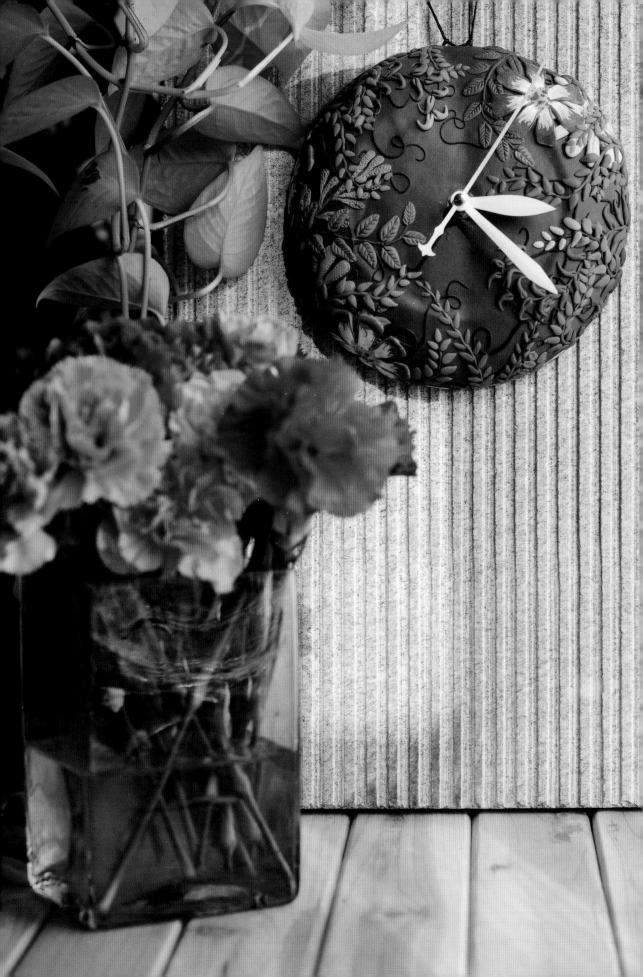

Preface

Polymer Clay has a high plasticity which makes it easy for modeling. After baking in the oven between 130° and 160°C, it can be permanently hardened. Different brands of polymer clay have different formulas. Some become solid after baking, which are good for creating miniatures, jewelries, and ornaments. Some retain certain levels of plasticity, which are good for making mouse pads. The uniqueness of texture and wide range of color embellish our life style in every aspect. We can create our own designs using the proper polymer clay to present our personality and style.

I was born in the 1970s and brought up in traditional art education, such as Chinese painting, clay sculpturing, and dough figuring. I have experienced the thirty years of rapidest development in China. The advancement of the Internet and the influence of multiculturalism have predominately impacted my art approach and design. The origin and development of polymer clay were outside of China. After falling in love with polymer clay, I have been thinking to infuse the Chinese style into this flexible material to make it an oriental art. The ideas can be derived from the perfectionism of Zen practice or the natural composition of Chinese painting. The possibilities are limitless as long as keeping the deep passion for art and life.

This book borrows some traditional Chinese sculpture techniques; for instance, clay sculpturing and dough figuring. These three dimensional art techniques have been with us for a few thousand years and are part of Chinese folk art. The themes are mainly derived from folktales, having lots of special characters, simple and yet having a sense of cuteness. Dough figures were developed from traditional Chinese food culture, presenting a unique style.

Besides infusing polymer clay with clay sculpting and dough figuring to acquire the common resonance, we can also look for some elements from Chinese traditions. A good example is the *zongzi* from the Dragon Boat Festival, using the leaf wrap as an idea to create a nut bowl. The traditional Chinese New Year Pictures are the good references of folk customs that can be turned into a series of polymer clay images. Getting the inspiration from Chinese ink wash paintings, we can take the sacred lotus as the theme and use the modern material epoxy to present the fusion of tradition and contemporary—the unique composition and concept of ink wash paintings presented in crystal-like modern material. You will also find the twelve zodiacs, Chinese food, calico, and many more.

We hope that these interesting crafts will open the door for you and add more sparkles to your life.

Facing page
The Clock
Designer: Han Han
This clock is actually made from an old pot lid. It had a crack but I was very reluctant to let it go. So I tailored a jacket and utilized its curve to turn it to a beautiful flower clock. Now it can continue to be with me forever.

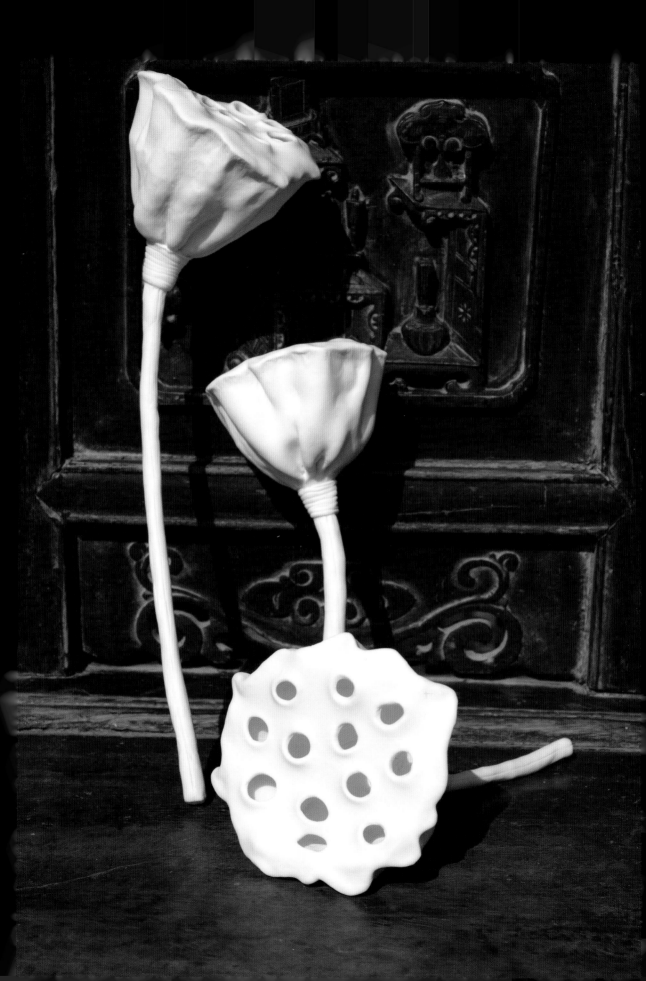

CHAPTER ONE
Getting to Know Polymer Clay

Polymer clay is a type of low temperature polyvinyl chloride material that requires baking for curing. Due to its stretchability, plasticity, and wide range of color that can form various colorful images and figures, polymer clay has become a vogue and fulfilled lots of dreams. Until now, it is still the most popular DIY material.

1. Characteristics

Polymer clay has no poison, odor, and irritation. With the gloss and oil nature, it is water resistant, not easy to dry out and be damaged by bugs. It can be kept for a long time. Comparing to other materials, polymer clay has lots of special characteristics that make it unique in craft making.

Wide range of colors. The traditional clay has only a few colors. Polymer clay used to have limited options when it first came out. After a long development, it, however, has been expanded to hundreds of color selections. You can easily mix and match to create whatever color you want and the color mixture can be preserved forever. This is like having the professional color palettes that remove you from the restriction of color options. The only limitation is your imagination.

High plasticity. Polymer clay has a high elasticity and plasticity. It can be stretched into thin strips and molded as a ball. It can be flat or three dimensional. Through cutting, assembling and matching with the techniques of twisting, kneading, rubbing, and nipping, a piece of unattractive polymer clay can be transformed into various interesting elements. These elements can be further assembled into different artworks. This actually is the greatest fun of polymer clay making. The elasticity and plasticity generate creativity. You can incorporate your own ideas and creativity into the polymer clay crafts to express your personality.

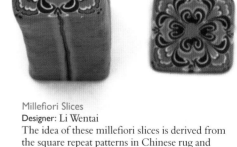

Millefiori Slices
Designer: Li Wentai
The idea of these millefiori slices is derived from the square repeat patterns in Chinese rug and clothing technique.

Facing page
The White Lotus Seed Pod
Designer: Mu Gua
This work expresses the characteristics of the lotus "growing out of the mud but inheriting no dirt" as described in the poem. The lifelike details highlight the simple and rustic nature.

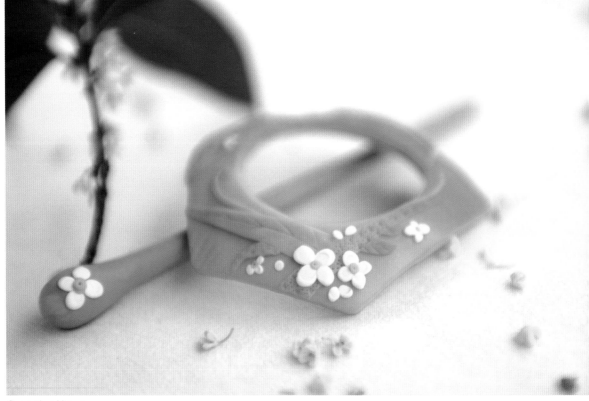

Osmanthus Hairpin
Designer: Mu Gua
The scattered osmanthus on this polygon hairpin send out a pleasant fragrance while the yellow and green color combination provides a natural scene.

Limitless creativity. The advantages of wide range of color and high performance of plasticity mentioned above set the excellent base for the third characteristic. Creativity is developed by one's experience. Immersing it in polymer clay making can generate a unique piece of art. Polymer clay can be combined with fabrics, wood, metals, and paillettes to form figures, jewelries, household essentials, and decorations. You can also develop different styles, such as classic, minimalism, and cute style. You can also change the color with oil-based coloring after curing. The flexibility of creativity is fully exposed.

2. Infusing with Chinese Elements

Polymer clay is a western material. You can get an astonished result when blending it with Chinese elements. They are not limited to Chinese symbols and styles but also traditional techniques and arts.

Traditional clay sculpture and dough figurine. As a traditional art, clay sculptures are commonly presented in the form of human and animal figures. The concepts are derived from folk stories and myths. After the drying of clay, base coat is applied with coloring on top. They are true to life and colorful. Dough figurines are made of flour. They are collectable as well as edible. The themes are commonly based on everyday life. The

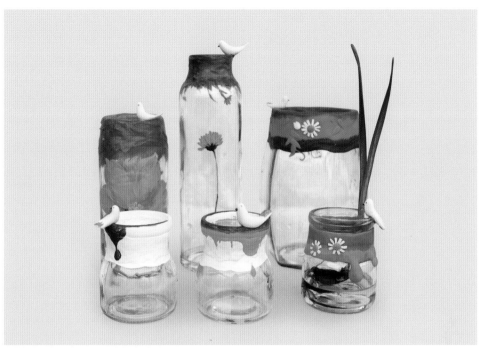

Encounter
Designer: Mu Gua
The birds are resting on the rims of the jars. It seems like having a lovely encounter with the chrysanthemums.

materials of these two folk art and polymer clay are alike. The skills and coloring techniques are interchangeable. Blending the ancient art with this contemporary material can glow new vitality.

Chinese painting. The themes of traditional Chinese painting are mainly on figures, landscapes, plants, and animals in the styles of *gongbi* or freehand. The references, images, and presentations can truly reflect Chinese traditional philosophy and aesthetic principles, expressing the theory of the integration of human and nature. Chinese painting is emphasized on artistic spirit and expressed in the forms of lines and strokes, similar to calligraphy, with the sense of freehand. It pays attention on the concepts but not relative perspective. It does not care about the background and prefers blank space. It mixes reality with imaginations. For example, a plum blossom can be simply hanging in the air without other objects around. If you can think outside the box, skillfully use coloring and techniques, you can also convey the thick and solid polymer clay to a poetic style like Chinese painting.

Painted Porcelain Teapot Restoration
Designer: Mu Gua
This teapot has once lost its handle. It is restored using polymer clay and decorated with a little panda. Isn't it unique even though the color and images are quite different?

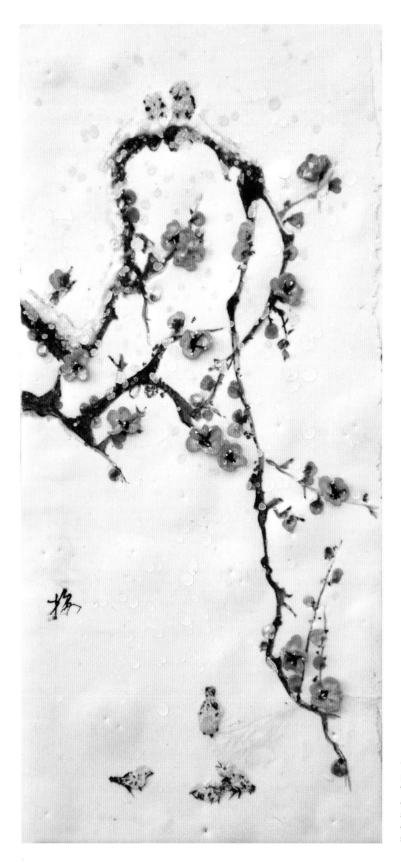

The Blooming Plum Blossoms
Designer: Jiang Shan
The plum blossoms are blooming on the mountain while the birds are glancing around. This polymer clay picture generates a beautiful scene.

Festivals. A festival is a custom and tradition developed in a nation after a long period of time. It can be attached with a significant historian or an important event. A lot of associations have been established during celebrations and become the symbols of a nation. Chinese New Year, the Lantern Festival, Qingming Festival, Dragon Boat Festival, the Mid-Autumn Festival have their own ways of celebrating; for instance, playing firecrackers on New Year, viewing lanterns and sharing dumplings on the Lantern Festival, racing dragon boats and eating *zongzi* on Dragon Boat Festival, watching the moon and tasting the mooncakes on the Mid-Autumn Festival. Adding these oriental elements into polymer clay making not only elevate the festival joy but also gain a better understanding of different cultures.

Auspicious associations. In the ancient time, people showed a lot of respect and curiosity about the mysterious universe and creatures. They expressed their thoughts on various images, figures, animals, myths, and wares through metaphors, puns, and homophones. These associations not only related to history but also folk features, demonstrating their wish for peace and blessings. For instance, fish is a homophone of "surplus" in Chinese, meaning "surplus year after year." You can find a number of crafts related to fishes in this book (on pages 34 and 71). *Fenghuang* or phoenix is an auspicious symbol. You can make an art with its image to display vitality and dignity.

3. Application and Preservation

Polymer clay can be produced into various accessories, miniatures, and ornaments to decorate your home as well as providing practical use. It, however, is a low temperature polyvinyl chloride material which does not last under high heat. Due to its high plasticity and elasticity, it is not as hard as ceramic and glass. It may be distorted when having a direct contact of heat. Thus, try to avoid holding hot items.

Polymer clay does not deteriorate under room temperature. It does not dry out since there is no water content inside. For preservation, wrap the non-baked polymer clay with foil, tissue, wax paper, or plastic wrap and place it in a cool place away from sunlight to avoid the direct contact of ultraviolet and high temperature, which may cause distortion.

The baked polymer clay items can be washed and wiped. No need to worry about fading and cracking. You can apply a layer of lacquer or epoxy to provide a glossy finish after cleaning.

Peony Pendant
Designer: Han Han
The blooming peonies deliver a graceful scene whereas the red and blue color combination portrays the Northern China folk features.

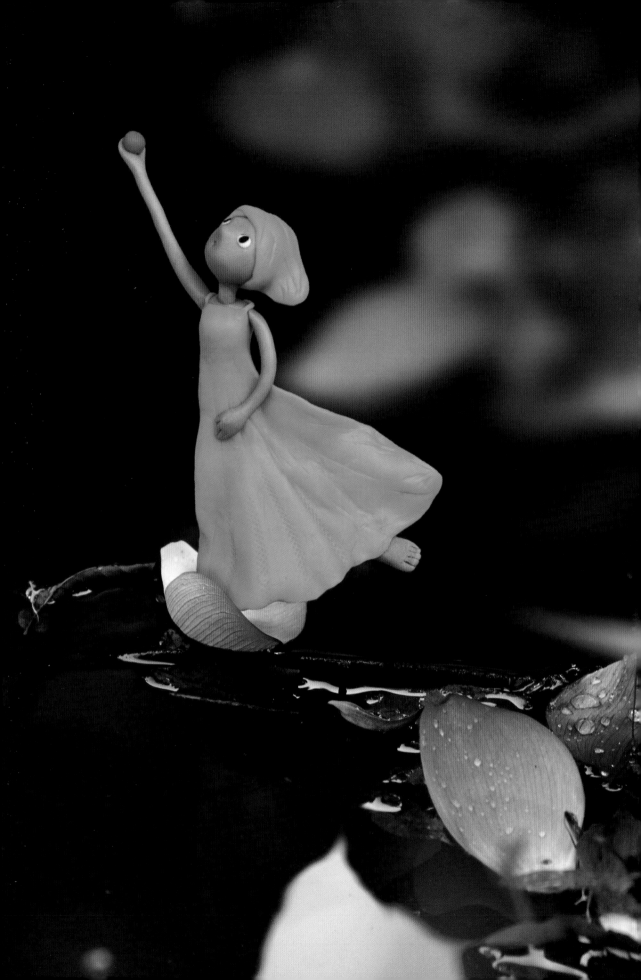

CHAPTER TWO
Preparations

T o do a good job, one must sharpen his tools. When crafting polymer clay, you need tools, no matter they are professional or everyday items. Any objects that you can find can be part of your equipment. All you need is to open your mind and you will find a lot of surprises all around. Every polymer clay art can carry a little story about you. Of course, the most important tool is your hands.

In this chapter, we will also talk about the techniques of color mixing and millefiori making. Grasp the fundamentals to elaborate your ideas.

1. Tools

There are two main types of polymer clay tools: knives and rollers. Knives are mainly used to cut and carve, making the edges smoother and the shapes closer to your design. Rollers are used to soften polymer clay, setting the clay more even and the thickness closer to your idea. It can also be used to create the gradient effect.

Exacto blade is used to trim the edges to perfect the art.

Long and short blades (stainless steel) are used to cut polymer clay. As they can be easily bended, different shapes can be cut as desired with smooth edges.

Sculpting tool set is used to create various patterns, such as spotty, jagged, and serrated surfaces, to enhance the textures. There is no limit. You can also use any tool with patterns to replace the sculpting tools.

Awl is used to score the polymer clay surface to produce the desired patterns.

Rolling pin is used to press and smooth polymer clay.

Roller is used to form the gradient sheet, blending various polymer clay by rolling it back and forth.

Pasta machine is used to roll polymer clay with less effort. It can be electric or manual. Polymer clay tends to get harder when it is cold. It takes a lot of effort to rub with a rolling pin. Passing the clay a few times through the pasta machine can easily generate the desired effect. There are usually 6 to 9 settings; the lower the number, the thicker the clay to be rolled out. The thinnest is 1.0 mm and the thickest is 3.5 mm.

Facing page
The Lotus Fairy
Designer: Mu Gua
The cute Lotus Fairy is having fun on the lotus leaves under the full moon.

Polymer clay extruder is used to squeeze out different shapes by utilizing various discs. In this book, we use the screw-type, which saves a lot of energy than the direct injection type.

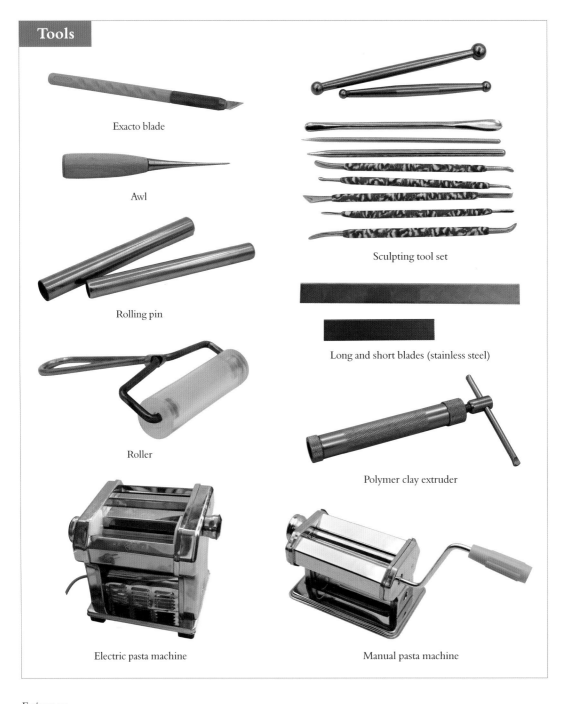

Tools

Exacto blade

Awl

Rolling pin

Roller

Electric pasta machine

Sculpting tool set

Long and short blades (stainless steel)

Polymer clay extruder

Manual pasta machine

Facing page
Pure
Designer: Zou Rui
This polymer clay bangle reflects the freshness of the nature through its smooth texture and warm color tone, staying away from the hustle and bustle of this world.

Maple Pendant
Designer: Jiang Shan
The maple leaf veins are transferred into the red pendants to remind us the most memorable season.

2. Materials

There are two main types of materials. One is polymer clay and the other is the supplementary materials. The latter ones are the items that are required to fix, decorate, and secure the clay during the making process.

Polymer clay has many brands, which come with different stiffness, texture, plasticity and stability. Some are stickier than the other. Choose according to your design.

Molds come with different forms for casting polymer clay to different shapes.

Chalks, and **mica powder** add colors to polymer clay to enrich both the tone and texture.

Polymer clay glue becomes harder under high heat. It can connect various clay components and accessories permanently after baking.

Clear epoxy is commonly used for models and replicas to provide a glossy finish. It has a low viscosity, high transparency, and reliable durability. It comes with two components. Pay attention to the application ratio when mixing. There is also pre-mixed epoxy available in the market.

Aluminum foil (plastic coated) is used to wrap around the molds so that the polymer clay can stay on the surface.

Plastic wrap is commonly used to wrap millefiori rods before placing them in the

> **Tip**
>
> When making polymer clay, first is to rub it with your hand or a pasta machine to soften it. If it gets too soft, you can roll it into a sheet and place the sheet between 2 pieces of paper to absorb the oil. This will make the clay a bit harder for easy modeling.

freezer to avoid distortion. It can also be applied on the polymer clay sheet for easy rolling and pressing with a rolling pin or roller.

Baby powder is good for preventing polymer clay from being too sticky to the tools.

Protectant comes with glossy and matte finish. It can change and protect the surface texture.

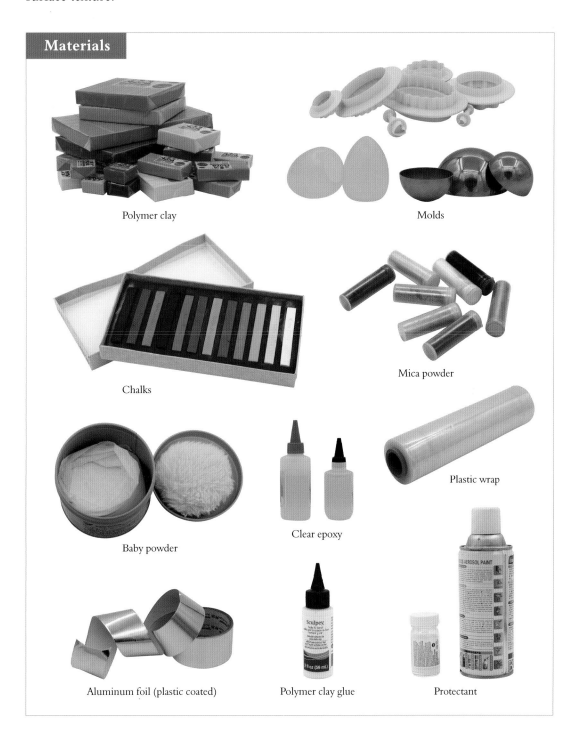

Materials

Polymer clay

Molds

Chalks

Mica powder

Baby powder

Clear epoxy

Plastic wrap

Aluminum foil (plastic coated)

Polymer clay glue

Protectant

3. Baking

Polymer clay requires baking to be cured. The most popular devices are oven and heat gun.

Regular **oven** for home use, 25-liter or 42-liter, is good enough. It is not recommended to use toaster oven that is too small since the craft may be burnt by the heating elements in the oven. During the baking process, place a piece of foil (not plastic coated) between the art work and the top heating elements to avoid the direct contact. Use a ceramic tile or baking tray as a base. The temperature is commonly set between 130° to 160°C and the bake time is around 20 to 40 minutes. Of course, every oven is different. It is suggested to test with a small piece of polymer clay to get a better understanding of the temperature and time.

Heat gun is used to cure small or thin polymer clay components, saving a lot of energy and time. However, the heat coming from this manual equipment may not be evenly distributed to the craft. If you want to have a perfect curing, baking in the oven is the best option.

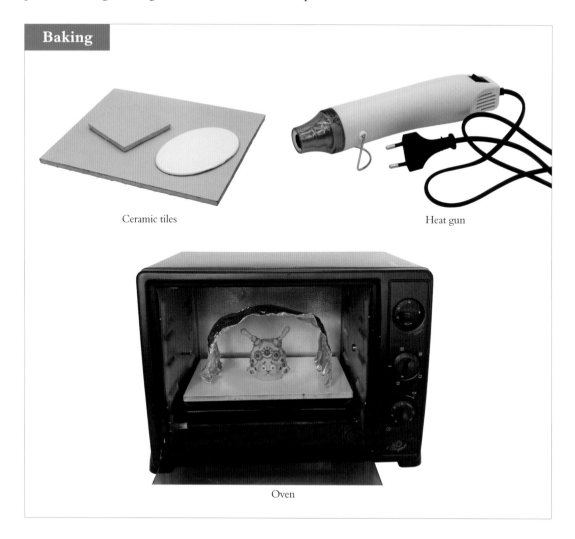

Baking

Ceramic tiles

Heat gun

Oven

4. Basic Techniques

Besides tools and materials, do not forget about the principles—skills and ideas—when working on polymer clay. Your skillful hands can convert the clay into various components; your creative ideas can embellish the clay to be more attractive. In this session, we will introduce the basic knowledge of color, color mixing, gradient color, and millefiori.

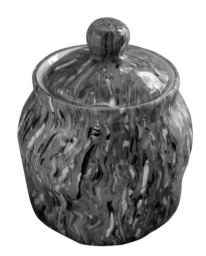

Green Tea-Leaf Jar
Designer: Jiang Shan
Tea-leaf jar is a common household item in China. This particular one combines various colors like a kaleidoscope to brighten our home.

Basic Colors and Color Mixing

Polymer clay has a lot of color options. It usually comes with 12 or 24 combinations. Some brands have even more. You can mix various colors by rubbing as well as applying color powder before baking to enhance the layering effect. Then what are the basic colors? How to mix different basic colors?

Basic Color Knowledge

Red, yellow and blue are the primary colors, which cannot be further unmixed. Integrate these three colors in different ratios can generate a full range of colors. Blend them in equal proportions results in white.

A secondary color is a color made by combining equal portions of two primary colors. Mix red and yellow will get orange; blend yellow and blue will form green; integrate blue and red will generate purple.

Color mixing is very fascinating. Some colors are warm and bright; some are dark and dull. If you want to get your desired colors, you may not be able to reach your goal in one shot. Practice makes perfect!

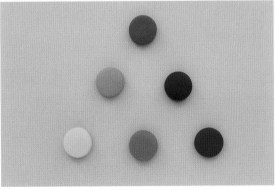

Color Mixing Techniques

After learning the basic knowledge of color, we will look into the color mixing techniques. If you keep practicing, you will learn the secrets of success.

1 Produce 2 clay sheets with different colors. Here we use purple and green. The sheets are in the same size and shape. Put them together as a rectangle.

2 Use a blade to cut the rectangle vertically into equal portions. As noted along the red line on the picture, the ratio of the purple clay becomes less towards the right while that of the green clay grows more. If the red line is level, the ratio of the 2 clay is the same, which means only one color can be generated. The angle of the red line displays the ratio of the color mixture.

3 Roll each portion into a pellet, fully mixing the 2 colors. You can find that the colors of the pellets are changing gradually from left to right. The leftmost one is more on the purple tone whereas the rightmost one is more on the green tone. By referring to the picture in step 2, the leftmost clay strip contains higher ratio of purple clay while the rightmost clay strip carries higher ratio of green clay. Obviously, the proportion of color selections has a direct impact on the final result when mixing the colors, no matter it is two or more colors.

Gradient Colors

Color mixing can generate only one color. How can we produce a color gradient? Here, we will introduce blending two and three colors to develop color gradient. When you grasp the principles, creating color progression of various colors will not be a problem at all.

1 First is to decide the shades that you want to generate. Choose 2 or 3 colors and rub them into pellets.

2 Use your palm to roll them into tapered rods. Arrange them in alternating directions.

3 Push the rods closer together and use a roller to flatten, making the rods stick to each other without gaps.

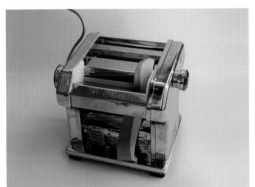 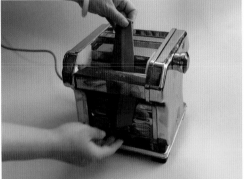

4 Pass it through a pasta machine in setting 1. Note that the clay always goes from top to bottom. Do not reverse.

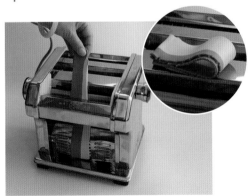 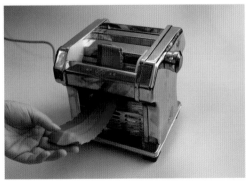

5 After pressing the clay into a long piece, fold it into half. Then pass it through the pasta machine from the top again in setting 1.

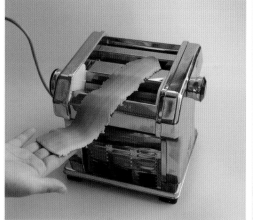 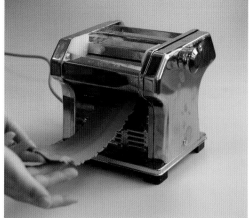

6 Repeat a few times. Note that it is pressed in the same direction.

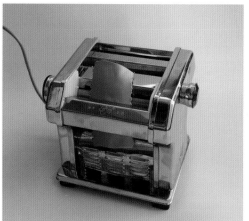 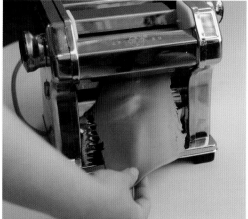

7 You can find that the clay piece gets wider and the gradient effect becomes more obviously.

8 Use a blade to trim the edges and a gradient sheet is formed. You can use the same method to integrate more colors to make the clay piece more vibrant.

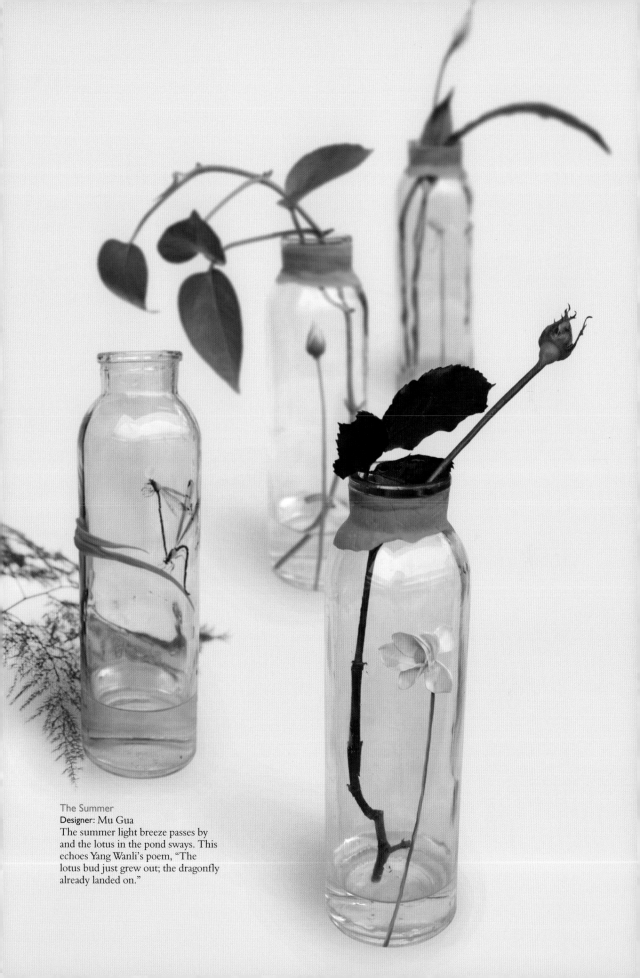

The Summer
Designer: Mu Gua
The summer light breeze passes by and the lotus in the pond sways. This echoes Yang Wanli's poem, "The lotus bud just grew out; the dragonfly already landed on."

Making Millefiori

Millefiori is an essential polymer clay crafting technique by arranging different color clay rods to form different patterns. The production involves rubbing the rods back and forth and then slice. The patterns become viewable from the sections. You can position the slices on various areas of the craft according to your design. Your innovative ideas can then be beautifully integrated into your intricate art piece.

Here, we will introduce two millefiori techniques: gradient millefiori and pattern millefiori.

Gradient Millefiori

This type of millefiori is simply based on a gradient clay piece with the use of a pasta machine.

1 Fold the gradient clay piece twice perpendicularly to the color transitions.

2 The clay piece then becomes a strip. Use a roller to flatten it.

3 Pass the strip through the pasta machine a few times while gradually changing the dial to a higher number. If you use dial setting 1 (the thickness setting) to roll the strip, the result will not be as favorable since the color transition detail is quite rough.

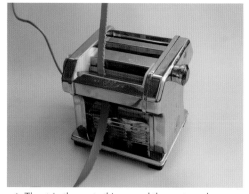

4 The strip then gets thinner and the center color transitions become smoother. Roll it up and you can see the color progression details.

Millefiori Slices
Designer: Jiang Shan
Do the various colors and geometric patterns look like the art style of Picasso?

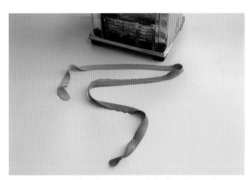

5 You can see that the short and thick rod piece has become long and thin.

6 Roll it up from one end. Be tight, not loose.

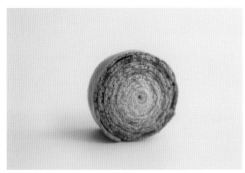

7 Rub the center of the rod so that it will be thinner and the color transitions will be merged together.

8 If the clay rod is too soft, it will be distorted when slicing. To solve the problem, wrap the rod with plastic wrap and place it in the freezer for about 20 minutes (the time required depends on the freezer temperature and the size of the item). This makes the cutting a lot easier.

The Swastika and *Fu* Character Millefiori
Designer: Li Wentai
Millefiori is not limited to the collection of various patterns. These two millefiori rods are fused with Chinese traditional patterns—characters of *shou* (寿 , long life) and *fu* (福 , blessing)—the symbols of longevity and prosperity. Isn't it a pleasant change?

Pattern Millefiori

This type of millefiori is a collection of polymer clay rods of different colors, sizes, and shapes being fused together to form an integrated rod. It requires extra attention to the rubbing process as it may affect the patterns.

1 Make a clay rod with the white polymer clay.

2 Create a smooth blue clay sheet and wrap it around the white clay rod.

3 Rub the bicolor rod until it is long and even.

4 Cut the rod into equal portions.

5 Pick 2 rods and press one side to form a teardrop profile.

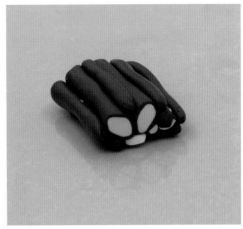

6 Make a few blue clay rods. Assemble them with the round and teardrop bicolor rods as shown in the picture. Now the rods are gathered to form a big clay piece.

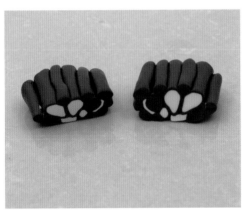

7 Repeat to create another piece.

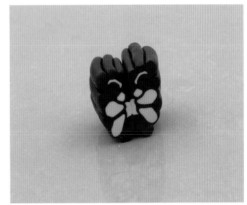

8 Join the 2 pieces to form the pattern. Doesn't it look like a butterfly?

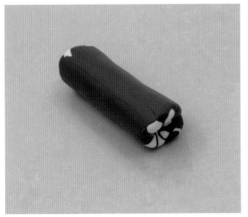

9 Gently rub the piece from the middle to eliminate the gaps between the rods. Do not rub it too hard to distort the design.

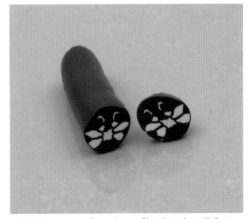

10 You can see from the profile when the millefiori rod is done. Slice and arrange them to create your own design.

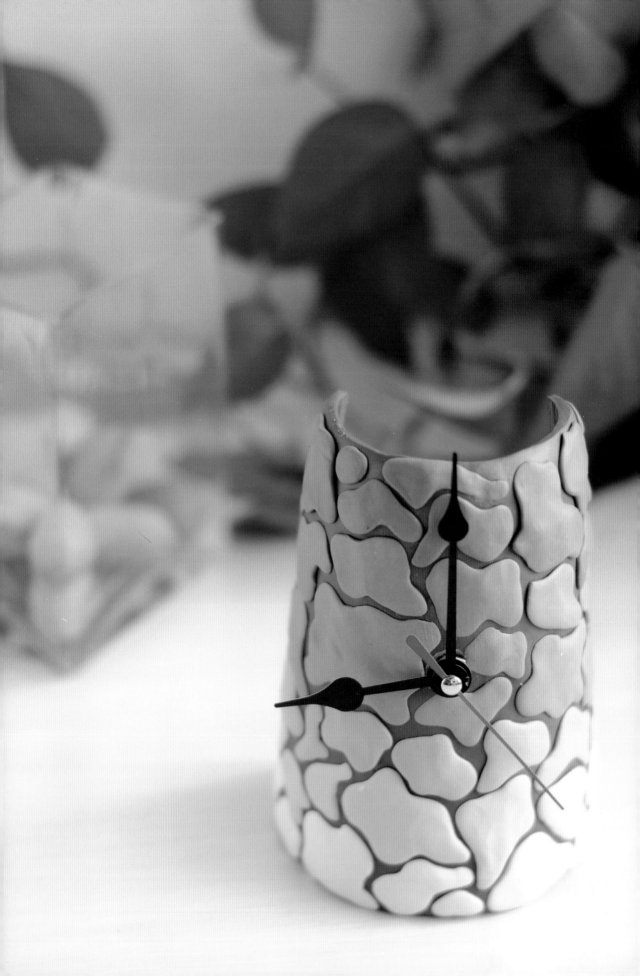

CHAPTER THREE
Introductory Lessons

After learning the basic techniques and setting up the tools, let's make some polymer clay crafts together! The lessons in this chapter are pretty easy to learn which are good for beginners. Whether it is a "*zongzi* leaf nut bowl" or an abstract "shoal of jade fish," you should be able to handle it with ease. Don't you think that it is a remarkable accomplishment as your artwork can be used for a long time?

1. Ink-Wash Painting Bookmark

Chinese ink-wash painting emphasizes on artistic concept and it is very difficult to fathom the techniques. How to arrange the composition to present the abstract artistic concept? Here, we will introduce a simple way to develop a Chinese style craft. Let's try together!

What You Need

Components	Polymer Clay Colors
Bookmark	Shades of green
Tools: pasta machine, exacto blade, rolling pin, long blade, printer, toothbrush	
Supplementary Materials: *xuan* paper, ink brush, ink	

Facing page
Stone Clock
Designer: Han Han
This old stone wall is made of gradient clay pieces mimicking the stone pattern and shape. Its clock seems to tell us everything about the past.

1 Randomly ink-brush on the *xuan* paper with tonality and shading. Take a photo or scan the design.

2 Arrange the images on the computer. Add some Chinese calligraphy or poems on the empty space. You can also add other scripts or images. Then mark the picture into 5 equal sections.

3 Mirror the picture and print. The figure illustrates the printout.

4 Use a pasta machine to produce a gradient green polymer clay sheet in 2 mm thick with the lighter shades along the edges.

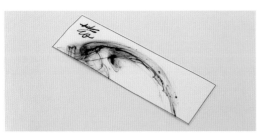

5 Cut out a section of the printout.

6 Place the image downwards on the polymer clay sheet.

7 Use a rolling pin to rub it a few times. You can also use your finger tips to massage it.

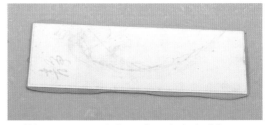

8 When you can see the image from the back of the paper, the paper sticks very well on the clay sheet and it is ready to bake the clay sheet together with the paper in the oven.

9 The paper and polymer clay are more bonded together after baking, which makes it difficult to detach.

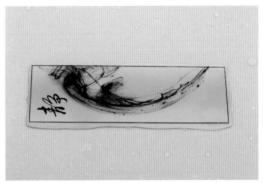

10 Wash the clay sheet and use a toothbrush to remove the paper. Then you can see the image being transferred on the polymer clay.

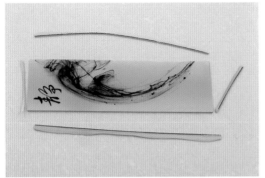

11 Trim and straighten the edges that are stretched out during the rolling process.

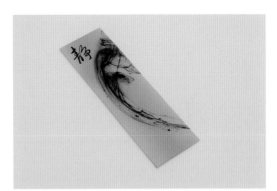

12 The bookmark is done.

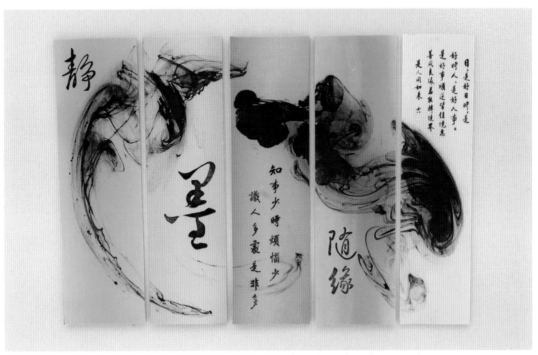

13 This method can transfer the images that you like onto the durable polymer clay as long as you have a printer.

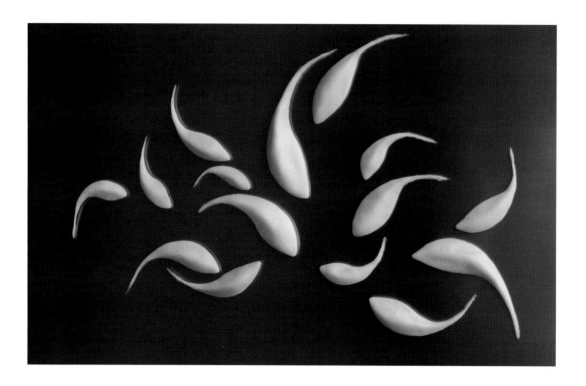

2. A Shoal of Jade Fish

China is the country of jade. This precious stone was first developed and utilized around seven thousand years ago. The long history and development have furnished it with Chinese traditions, philosophy, and culture. Its complex and virtuous nature is believed to have a unique spirit. Thus, it is used to represent kindness, righteousness, wisdom, bravery, and purity, as a symbol of propitiousness. In the old days, gentlemen and scholars always carried a piece of jade around to denote the practice of the code of ethics.

In Chinese, "fish" is a homophone of "surplus" representing "surplus year after year" and wealth. Jade fish ornaments, therefore, are one of the most popular traditional charms.

What You Need

Components	Polymer Clay Colors
Fish	Translucent white, olive green
Tools: rolling pin, stick	

1 Add a small piece of olive green polymer clay onto the translucent white one to generate the basic color of jade.

2 To produce the natural texture of jade, add different amount of olive green polymer clay onto the translucent white one. Then knead a number of polymer clay pellets in different shades of olive green.

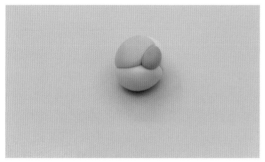

3 Combine the clay pellets and knead. Do not blend them entirely.

4 Use a rolling pin to flatten the clay piece and you can see the textures in various shades.

5 Then roll the piece into a ball. The random texture is now blended together.

6 Knead the ball into a carrot shape.

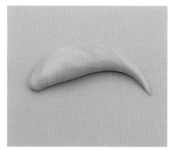

7 Continue to knead to form a fish.

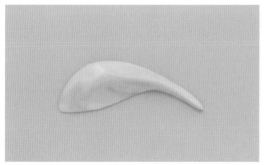

8 Pinch the back of the fish to form a gentle bulge.

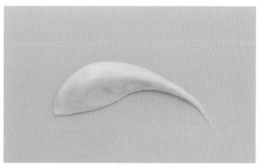

9 Squeeze the tail so that it is fine and sharp.

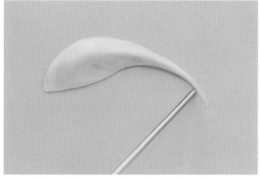

10 Use a stick to stretch the tail outwards so that it becomes thinner. It will be more translucent after baking to produce the luster effect.

11 Repeat the same steps to produce a number of fishes in different sizes. They can be facing different directions. Bake them in an oven and assemble your desired layout. You can place them on the fridge or use them as other decorations.

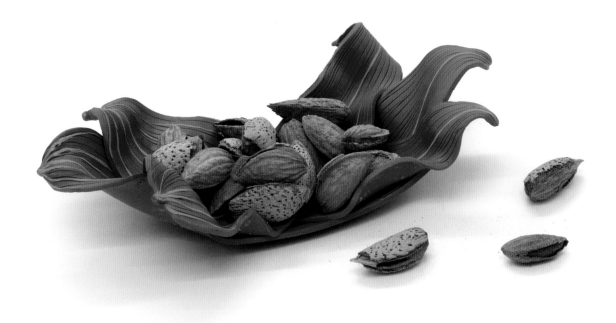

3. *Zongzi* Leaf Nut Bowl

The 5th day of the 5th month of the lunar calendar is the Dragon Boat Festival. It can be dated back to the Warring States Period (475–221 BC) to commemorates the death of the poet and minister Qu Yuan (340–278 BC). One of the traditions is to eat *zongzi* (sticky rice dumplings) and the leaf used to wrap the rice dumplings looks like a boat. Inspired by the shape of the leaf, we can make a nut bowl with a scent of the nature.

What You Need

Components	Polymer Clay Colors
Leaves	Green
Veins	Yellow-green
Tools: flat tip sculpting tool, paint brush, rolling pin	
Supplementary Materials: chalk (dark green), ceramic bowl, tissue, protectant (glossy or matte finish)	

1 Roll the green polymer clay into a flat piece.

2 Cut out a leaf.

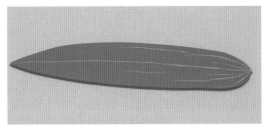

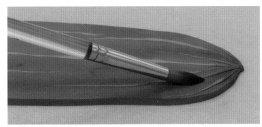

3 Rub the yellow-green polymer clay into long and thin strips of different lengths. They are the mid-vein and parallel veins. Place them on the leaf and roll to incorporate them into the leaf. Try to make the leaf surface smooth.

4 Scrape the dark green chalk. Use a paint brush to brush the chalk powder onto the bottom of the leaf to enhance the color.

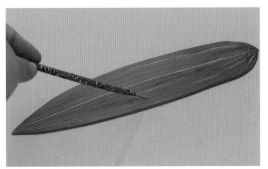

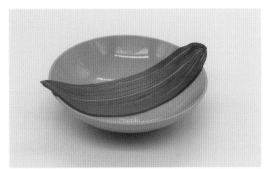

5 Use the side of the flap tip sculpting tool to score a series of parallel lines. Repeat the above steps to create another 2 leaves.

6 Select a flat ceramic bowl for retaining the leaf shape when baking. Place one of the leaves on the bowl following the curvature of the surface.

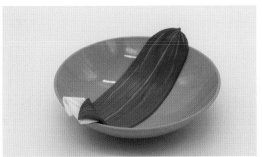

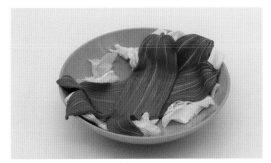

7 To make the leaf more realistic, you can set the tips out of the bowl and place some tissue to hold the shape.

8 Place diagonally the other 2 leaves on top and use the tissue to hold the shape. Put the bowl in the oven for baking.

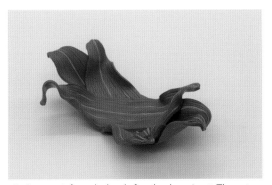

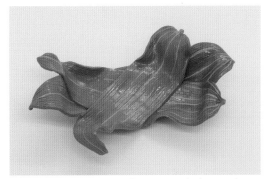

9 Remove it from the bowl after the shape is set. The nut bowl is finished.

10 We can apply a layer of protectant whether it is glossy or matte finish for easy cleaning. Note that this bowl is for nuts or other small articles, not for moist food items.

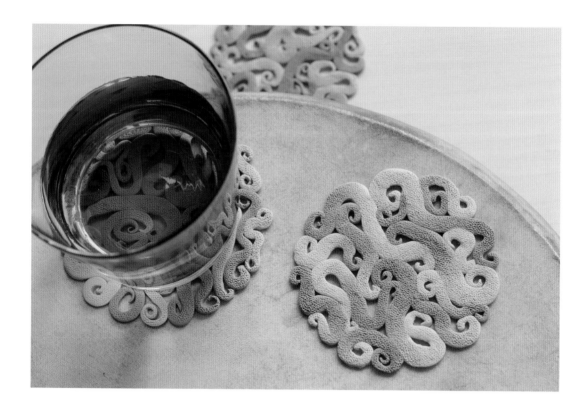

4. Cloud Coaster

Chinese cloud patterns are like birds fluttering in the sky, symbolizing luck and blessings. The gradient color adds more diversity to the clouds of different shapes, making the coaster revives like the water in the glass.

What You Need

Components	Polymer Clay Colors
Chinese cloud	Green, purple, sky blue, yellow
Tools: rolling pin, long and short blades, pencil, flat tip sculpting tool, brush, exacto blade	

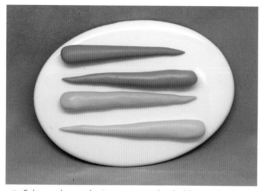

1 Select polymer clay in green, purple, sky blue, and yellow to provide higher contrast.

2 Roll the 4 colors into a gradient flat piece.

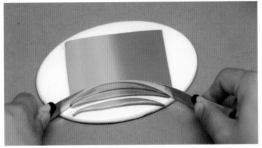

3 Bend the long blade to form an arc and cut out long pieces with pointed ends in different lengths. To increase the variety, be sure to select the proper area to cut.

4 Draw a circle on the ceramic tile to outline the perimeter of the coaster and place the piece within the circle.

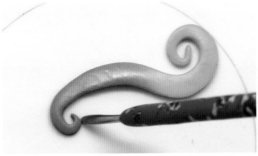

5 Curve the piece to form the Chinese cloud pattern. Use the side of a flat tip sculpting tool to turn the ends in spiral shape.

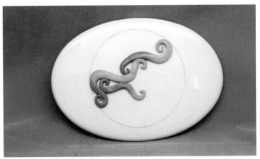

6 Note that the pieces are touching each other to form a connected piece and not loosing apart.

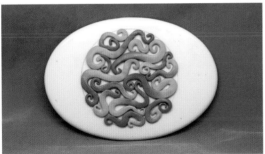

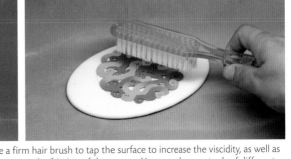

7 When the circle is filled with the polymer clay pieces, use a firm hair brush to tap the surface to increase the viscidity, as well as flattening the surface. The pores left on the surface can increase the friction of the coaster. You can also use tools of different surface texture to tap to produce a different result.

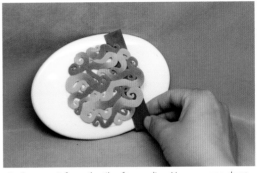

8 After tapping, some pieces may be stretched outside of the circle. Use an exacto blade to trim and shape it to be more circular. Then bake it in the oven.

9 Remove it from the tile after cooling. You can use a short blade to help remove since it may be a bit sticky. The coaster is done.

5. Blue and White Decoration

Blue and white ware is one of the most valuable porcelain arts. It can be dated back to the Tang Dynasty (618–907) and reached the peak at the reign of the Kangxi Emperor of the Qing Dynasty (1644–1912). Its pattern is simple, neat and elegant, having the same artistic charm as the Chinese ink wash paintings.

This piece of art is derived from the color combination and pattern of the blue and white wares, using simple technique to generate an unexpected visual delight. You can also use your creativity to modify the pattern and style to produce murals and decorative sticky pads.

Blue and white ware pattern

What You Need

Components	Polymer Clay Colors
Background	White
Tools: exacto blade, long blade, flat tip sculpting tool	
Supplementary Materials: rubber stamp, blue inkpad	

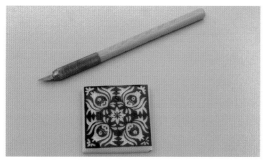

1 Draw the blue and white pattern or place an image downloaded from the web on the rubber stamp. Use an exacto blade to cut out the pattern.

2 Roll out a white square polymer clay piece.

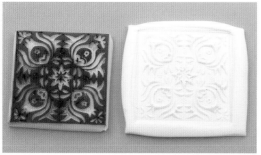

3 Press the patterned rubber stamp onto the white polymer clay piece.

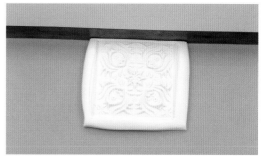

4 The edges become irregular after pressing. Trim them by a long blade.

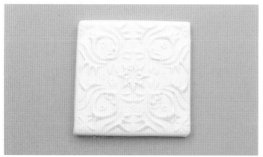

5 The square patterned piece is done.

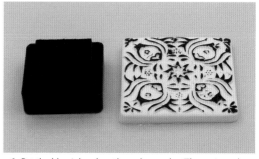

6 Pat the blue inkpad on the polymer clay. The projected portion becomes blue.

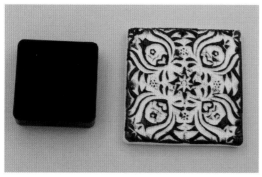

7 You can pat more on the edges to make it plumper like a traditional Chinese seal.

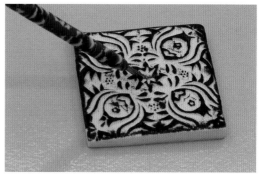

8 We are going to use this blue and white piece as a decoration attached on a treasure box using a wax cord. Thus, cut a slit in the center for threading the wax cord before baking. You can also modify according to your design.

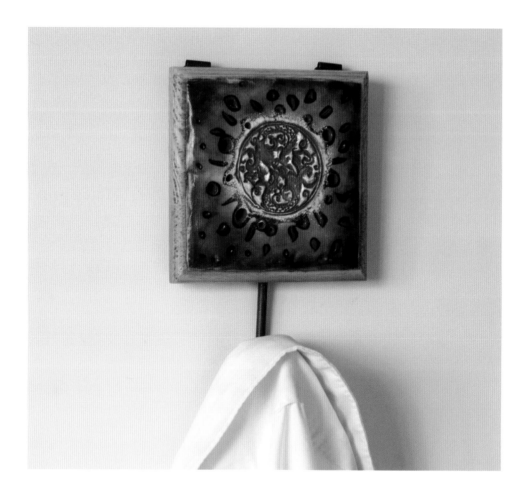

6. Phoenix Coat Hook

The phoenix pattern is one of the ancient bronze totemic symbols. The phoenix or *fenghuang* in the Chinese legend is believed to be the prettiest and master of all the birds. When it flies, all birds follow, which grants it the "King of Birds." Across all the ages, phoenix is a bird of auspiciousness. It often appears on poems, paintings, and home decorations to demonstrate the blissful desire.

This coat hook reflects the simple style of combining the ancient totemic symbol with the contemporary residential design, throwing out a unique beauty.

Phoenix pattern

What You Need

Components	Polymer Clay Colors
Base	Yellow, white, orange, black, brown

Tools: exacto blade, stick, short blade, rolling pin, flat tip sculpting tool

Supplementary Materials: rubber stamp, coat hook, polymer clay glue, mica powder (gold), chalks (purple, pink, black, red), white inkpad , matt water-based lacquer

1 You can draw a phoenix directly onto a rubber stamp or find an image online and place it on the rubber stamp. Then use an exacto blade to shape out the phoenix pattern.

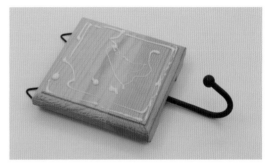

2 Apply some polymer clay glue onto the coat hook.

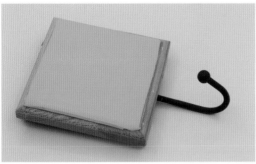

3 Roll a piece of yellow polymer clay into a square and paste it onto the hook. This is the first layer.

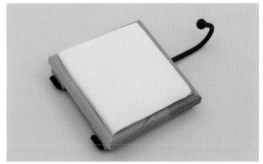

4 Then apply a white square polymer clay piece as the second layer.

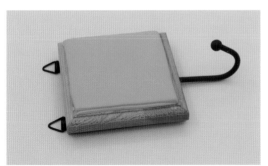

5 The third layer is an orange square polymer clay piece.

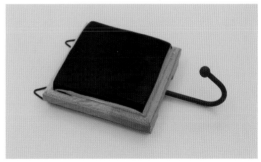

6 The forth layer is a black square piece.

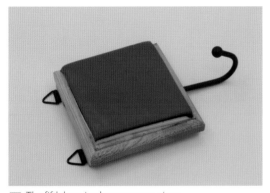

7 The fifth layer is a brown square piece.

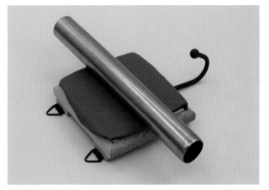

8 Rub the 5 layers with a rolling pin a few times until the layers are bonded together.

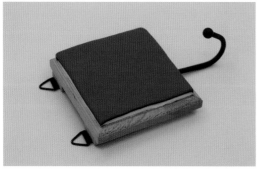

9 Trim the edges.

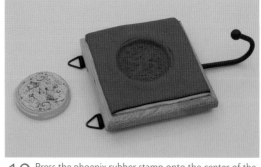

10 Press the phoenix rubber stamp onto the center of the polymer clay base.

11 Use the side of a flat tip sculpting tool to press a number of oval grooves in different sizes around the phoenix pattern. Do not carve all the way to the base of the hook.

12 Use the stick to create a number of round grooves in different sizes around the phoenix pattern.

13 Use a blade, tilted a bit, to pare the polymer clay around the phoenix pattern so that the center piece can be protruded and stand out.

14 Note that the tilted angle of the blade is to be gentle.

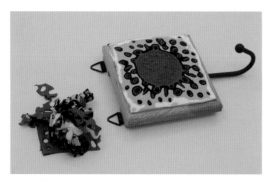

15 You can see the bottom layers to be exposed gradually.

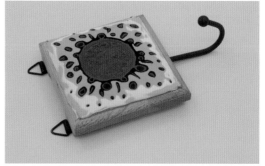

16 Now, the center of phoenix pattern projects out and the surrounding area in different colors slopes down.

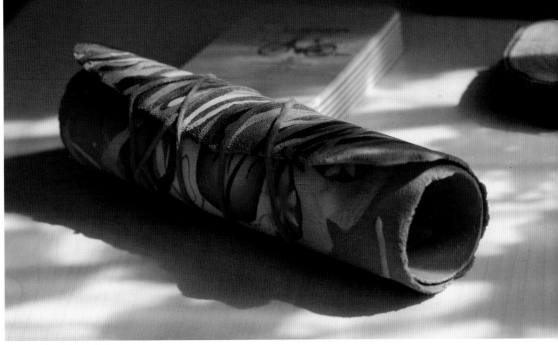

Polymer Clay Mouse Pad
Designer: Han Han
This is a rollable polymer clay mouse pad. Tying it with a brown leather cord makes it look like a traditional Chinese scroll.

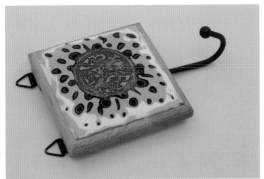

17 Apply a layer of gold mica powder onto the projected phoenix pattern.

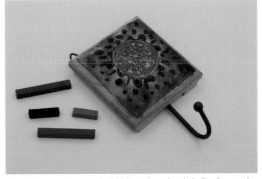

18 Scrape the purple, black, pink and red chalks. Smear the powder onto the slopes around the phoenix pattern to create an illusory effect to highlight the phoenix.

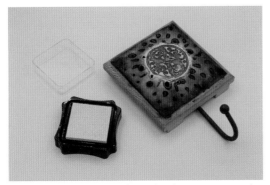

19 Press the white inkpad onto the phoenix pattern so that the projected pattern becomes brighter to promote the layering effect. Place it in the oven for baking.

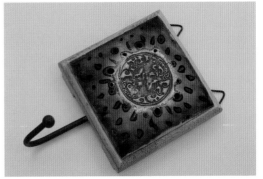

20 Apply a layer of matt water-based lacquer on top for protecting the surface and colors. The coat hook is complete.

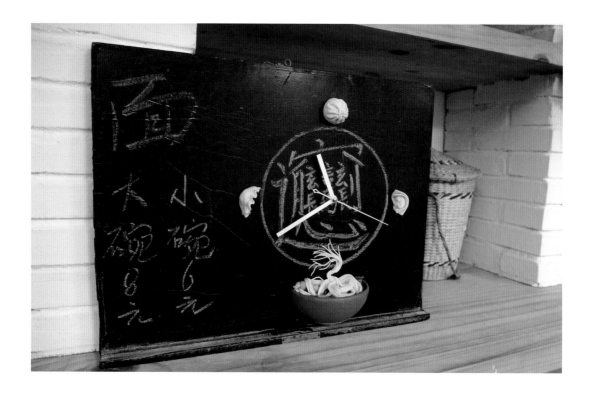

7. Flour Food Clock on Chalkboard

Chinese flour food has a very profound history that can be dated back to the New Stone Age. It has a great variety and is delicious. With the improvement of cooking utensils and appliances, the ingredients, productions, and varieties of flour food have been broadly elaborated, such as dumplings, noodles, spring rolls, and *zongzi*.

The word 𰻝 (*biang*) on the board looks very complicated. It is actually a collective name for all types of flour food. You will learn how to make the four most popular types of flour food after this lesson. Polymer clay and flour are quite similar. Let's try and taste it!

You can also use your creativity to modify the food and clock. This craft is a combination of time displaying and note taking, killing two birds with one stone.

What You Need

Components	Polymer Clay Colors
Wraps	White, translucent white
Bowl	Shades of brown
Noodles	White, translucent white
Shrimp	Peach, orange, yellow, red
Vegetables	Shades of green
Tools: long blade, rolling pin, polymer clay extruder, exacto blade, awl, paint brush, flat tip sculpting tool	
Supplementary Materials: chalk (red), foil, baby powder, super glue, clock with arms, chalkboard, glass bowl	

1 First is to make a bowl of noodles. Mix the white and translucent white polymer clay to mimic the color of the cooked noodles and create a dough.

2 Use a polymer clay extruder with various discs to squeeze out noodles in different sizes.

3 Arrange the noodles in the desired form and place them on a ceramic tile. Note that the arrangement has to match the bowl shape. Bake in the oven.

4 Rub the peach clay so that one end is tapered and the other end is round and thick.

5 Roll the orange, yellow and red clay to form a gradient piece. Apply the red chalk powder to mimic the color of cooked shrimp.

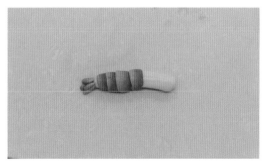

6 Wrap the above clay piece around the peach rod layer by layer. Note that the edges are overlapping. Cut a few pieces with a long blade to create the shrimp tail.

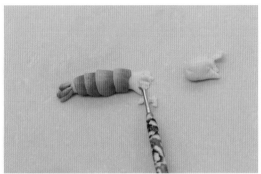

7 Pinch out part of the peach rod end. Score some lines to replicate the part where the shrimp head is removed.

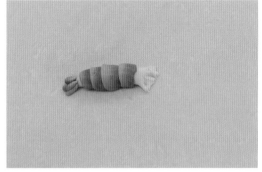

8 The shrimp is ready.

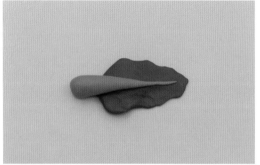

9 Make the green clay as the stalk and the dark green clay as the leaf part. Assemble as shown on the picture.

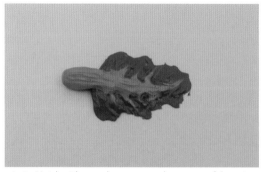

10 Notch with an awl to generate the texture of the veins.

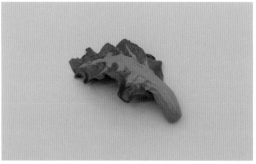

11 Use your fingers to curl the leaf edges.

12 Turn the glass bowl upside down. Place the brown clay sheet on one side of the bowl. Trim and smooth the edges. Then bake in the oven.

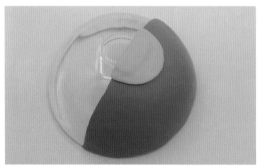

13 Make a half circle with the yellowish brown clay and place it on the bottom of the bowl.

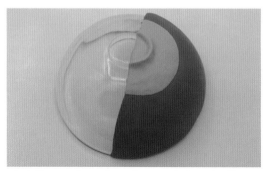

14 Use your finger tips to shape out the foot-ring. Then bake in the oven.

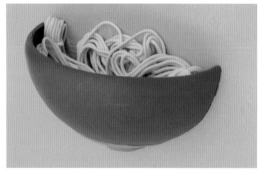

15 Arrange the noodles as shown.

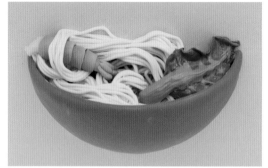

16 Arrange the veggies and shrimp as shown. The noodle bowl is set.

17 Next is to make a steamed bun. Mix together the white and translucent white clay and create a round piece.

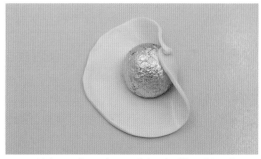

18 Make a pellet with some foil as the filling. Wrap the round clay piece around the filling. Push the edge towards the center.

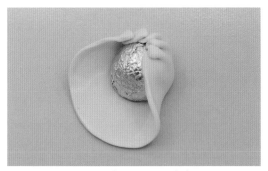

19 Continue to press the wrap towards the center in anticlockwise direction and make sure the folds are stick together on top.

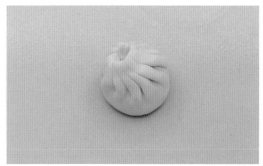

20 The miniature is almost done. There is a hole in the middle.

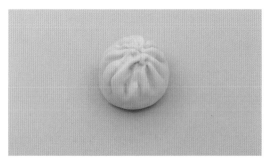

21 Press the hole towards the center. The steamed bun is ready. Bake in the oven.

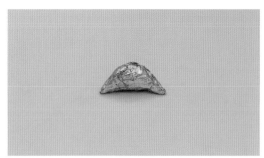

22 Next is to make a dumpling. Use some foil to make the filling that is round in the middle with the sharp tips on each side.

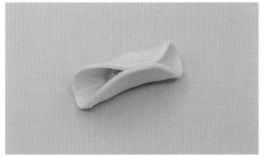

23 Mix the white and translucent white clay and roll it to a round piece. Wrap it around the filling symmetrically and close the middle.

24 Close the entire wrapping. The dumpling is roughly formed.

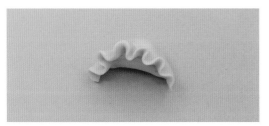

25 Use your finger tips to tweak the edges. Bake in the oven for curing.

26 Next is to make a wonton. Create a square piece and an oval pellet with a mixture of white and translucent white clay. Sprinkle some baby powder on the edges of the square piece to prevent them from sticking together. Wrap the square piece around the pellet.

27 Fold into half but do not press down so that the edges loosely touch one another.

28 Stand up the wonton and bend the right tip towards the center.

29 Repeat on the left and overlap the tips. Bake in the oven. The wonton is set.

30 Let's assemble the food. Drill a hole on the chalkboard.

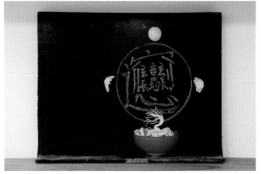

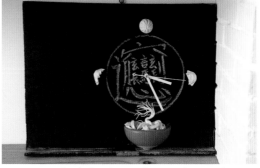

31 Write the word 𰻞 *biang* on the board using the red chalk. Attach the cured steamed bun, dumpling, wonton, and noodle bowl at 12, 3, 6 and 9 o'clock respectively using super glue.

32 Insert the clock and arms. The artwork is complete.

8. Wave Door Tag

The "sea and mountain" pattern is the traditional Chinese auspicious motif commonly found on the bottom portion of the ancient emperors' and officers' robes. It represents luck and longevity. In this piece of art, we further develop this traditional pattern and fully utilize the characteristics of polymer clay, generating a simple and streamline design, to give this ancient motif a new life.

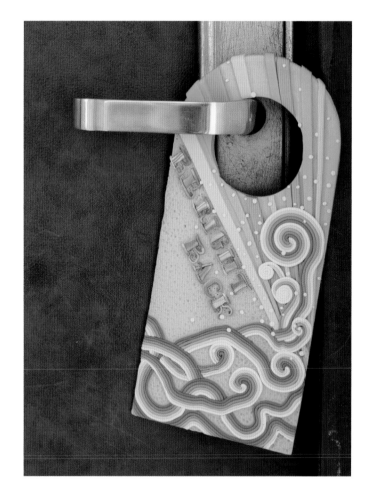

What You Need

Components	Polymer Clay Colors
Door tag	Orange
Sunrays	Red, yellow, orange
Waves	Shades of blue, shades of green, white
Tools: rolling pin, stick, long blade, polymer clay extruder, exacto blade	
Supplementary Materials: jar lid	

1 Roll a flat and smooth orange polymer clay sheet. Bend the long blade to cut an arc on one end.

2 Make several red, yellow and orange polymer clay strips in different lengths that tapered to a point. Radially arrange them on the door tag. They are the sunrays.

3 Use the Prussian blue, blue, light blue, light green, mint and white polymer clay to create waves. This variety of colors can enhance the layering effect of the waves.

4 Use a polymer clay extruder to produce long strips of the color mentioned above for later use.

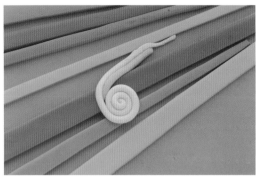

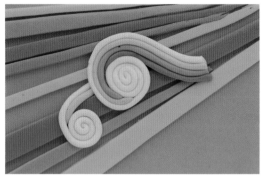

5 Coil the white strips to form a comma-shaped wave. You can also combine with other color strips.

6 Coil 4 different color strips to make another wave.

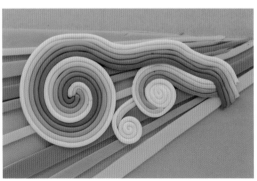

7 Try to create a bigger wave. This arrangement is like waves crashing into the cliff.

8 Next is to make the waves below that represent the calmer sea.

9 The gentle waves are in arc shapes.

10 You can create your own design and arrange the layout until the bottom portion is filled.

11 Use a jar lid to cut out a round opening from the door tag.

12 Next is to produce the phrase "Be Right Back." You can knead together the wave and sunray polymer clay pieces. Do not fully blend the different color strips.

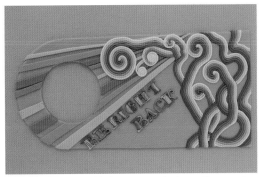

13 Roll the clay and you will find that the colors are intermingled together like a color illusion.

14 Use an exacto blade to cut out the letters. You can also create other phrases in different fonts.

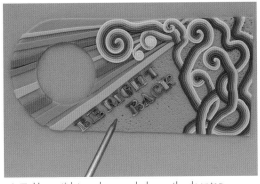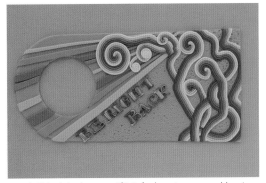

15 Use a stick to poke some holes on the door tag.

16 Bake it in the oven. If it is for long term use, add a piece of wood of the same size at the back for reinforcement.

9. Papercutting Napkin Ring

Papercutting is a Chinese folk art. The common media are paper, gold or silver leaf, tree bark, leaf, cloth, and leather. Using polymer clay to express the papercutting artistic concept of "seeking complexity from the simplicity, seeking harmony from the complexity, and seeking exception from the harmony" is quite a different approach.

The feature element of this craft is rat, the first sign of the Chinese zodiac cycle. In Chinese folklore, twelve animals were selected to be the representatives of each year of the cycle. They are rat, ox, tiger, rabbit, dragon, snake, horse, ram, monkey, rooster, dog, and pig. Find out which is your animal sign and create a special napkin ring for yourself.

Components	Polymer Clay Colors
Rat	Green
Tools: awl, exacto blade, flat tip sculpting tool, rubber tip sculpting tool, paint brush	
Supplementary Materials: glass bottle, mica powder (light green, pink, yellow, white)	

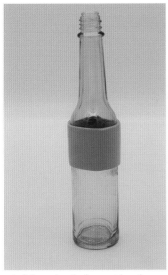

1 Select a bottle that matches the size of the napkin ring that you are going to produce. Rub a long strip with the green polymer clay and wrap it around the bottle.

2 Use an awl to pierce the outline of the rat on the polymer clay strip.

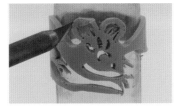

3 Following the outline of the rat, use an exacto blade to remove the polymer clay from the edge and void spaces. The rat shape is now a bit rough.

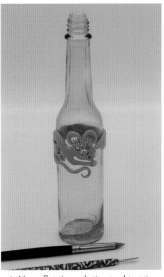

4 Use a flat tip sculpting tool to trim and patch the outline. Then use a rubber tip sculpting tool to press the edges to smoothen the outline.

5 Brush the light green, pink, yellow and white mica powder on the rat surface. You can also choose your own color combination.

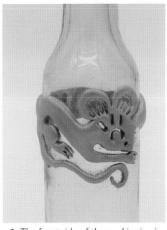

6 The front side of the napkin ring is done.

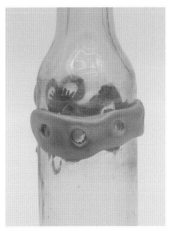

7 You can design the back of the napkin ring, such as cutting some holes as shown. Then brush the mica powder on top.

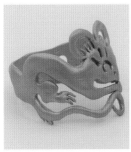

8 Remove the napkin ring from the glass bottle after baking.

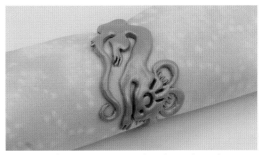

9 Repeat the same steps to produce the twelve zodiac signs. You can also choose one sign to create different styles for your napkin set. Use your creativity to achieve endless ideas.

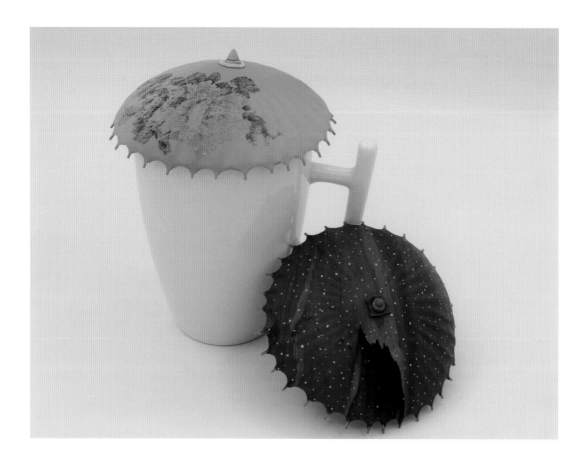

10. Oil-Paper Umbrella Mug Lid

The history of oil-paper umbrella can be dated back to a thousand years ago. It is made of hand-chopped bamboo strips with tung oil treated paper. It is not only a practical item but also an auspicious symbol. For example, the Chinese writing of umbrella is 傘 , that contains four small men under a big man (the Chinese character of "man" is 人). This carries a blessing of having many sons. The structure of the oil-paper umbrella is bamboo, which represents longevity and promotions. The shape is circular, which denotes perfect and peace.

This creative mug lid combines the practicality of oil-paper umbrella with the freehand style of ink-wash painting, revealing a very inspirational idea.

What You Need

Components	Polymer Clay Colors
Oil paper	Green, black, white
Cap	Brown, green
Ribs	Green, yellow
Tools: polymer clay extruder, pasta machine, flat tip sculpting tool, ball tip tool, long blade, exacto blade, scissors	
Supplementary Materials: glass bowl, aluminum foil	

1 Use a polymer clay extruder to extract some green clay strips.

2 Line them up on a ceramic tile and bake in the oven for later use.

3 Turn a glass bowl upside down. Use the aluminum foil to make a circle and place it on the bowl for positioning.

4 Produce a round yellow polymer clay piece and place it at the center of the bowl.

5 Place symmetrically and radially the green clay strips from step 2 on the bowl beginning from the center. Start with 4 strips and set in place with the aluminum foil.

6 Then place another 4 strips similar to step 5 in a symmetrical and radical layout.

7 Then place the left 24 strips.

8 Mix the green and black polymer clay.

9 Press the clay sheet with the pasta machine a few more times until it looks like what is shown on the picture. The result of this random blending and pressing is similar to Chinese ink-wash painting style.

10 Use the pasta machine to flatten the clay.

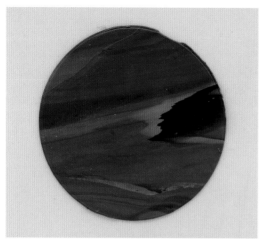

11 Cut a circle from the desired area.

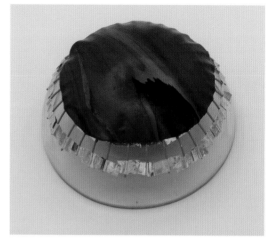

12 Place the circle at the center of the bowl. Gently use your palm to press the edge until it bonds with the clay strips. You can also apply some polymer clay glue on the strips before placing the circle to strengthen the bonding.

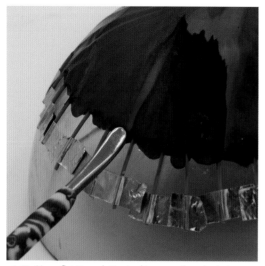

13 Use a flat tip sculpting tool to curve the edge between the strips.

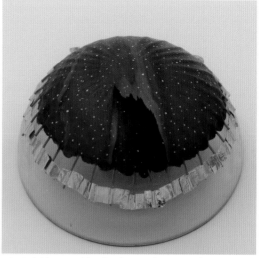

14 Add some white clay dots on the green oil paper. Doesn't it look like snowing in the forest?

15 Make a small square brown clay piece and place it at the center.

16 Shape the brown square to form some natural creases. Use a ball tip tool to press a small pit at the center.

17 Add a green pallet in the middle and create an indentation in the center. Then place another smaller green pellet above. The cap of the umbrella is done.

18 Bake in the oven. Remove the umbrella lid from the bowl. The figure shows the top view.

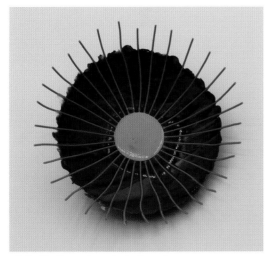

19 The figure shows the bottom view.

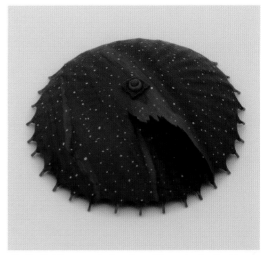

20 Cut the unwanted portion of the umbrella ribs. Use a flat tip sculpting tool to trim the edges between the ribs. The oil-paper umbrella lid is complete.

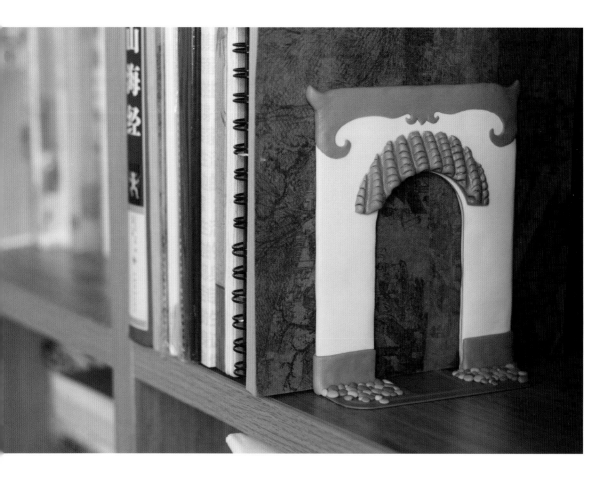

11. Chinese Courtyard Bookend

The traditional Chinese courtyard design was influenced by Chinese philosophy and painting. The famous examples are private gardens in Jiangnan regions (south of the Yangtze River) and Lingnan (now Guangdong, Guangxi and Hainan provinces). The design emphasizes on artistic concept, blending the abstract feeling with the scene. The color selection is very neutral, mainly gray and white, to portray the purity. The Chinese courtyard also focuses on culture, quality, attractiveness, and sophistication.

What You Need

Components	Polymer Clay Colors
Wall	White
Eaves	Gray
Tiles	Gray
Bases	Gray
Stones	White, shades of brown
Tools: scissors, exacto blade, stick, pencil	
Supplementary Materials: metal bookend, paper, polymer clay glue, straw	

1 Select a metal bookend. Apply a layer of white polymer clay on both sides. Be sure the surface is smooth. Bake it in the oven. The wall is done.

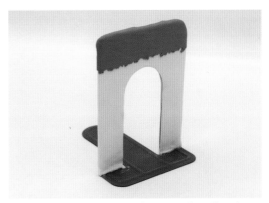

2 Next is to make the eaves. After setting the wall, apply a layer of gray polymer clay on the top portion of the bookend. Be sure there are no bubbles in between.

3 Cut a piece of paper as the same width of the bookend. Fold it into half and use a pencil to outline the pattern. Cut along the outline.

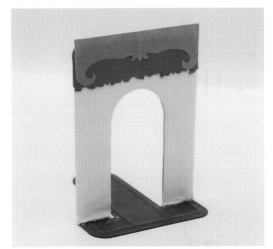

4 Attach the paper on the bookend as shown.

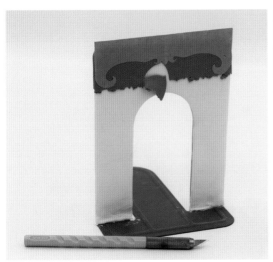

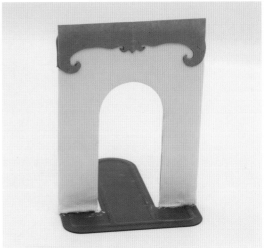

5 Use an exacto blade to trim out the unwanted portion of the gray polymer clay.

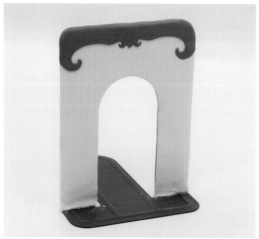

6 Remove the paper and use your fingers to smooth the edges.

7 Knead 2 small gray polymer clay pellets and place them at the corners of the eaves.

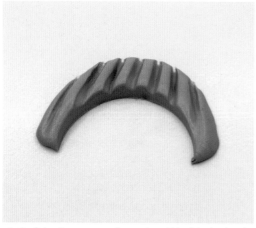

8 Use your fingers to shape out the desired angle and curve. The eaves are done.

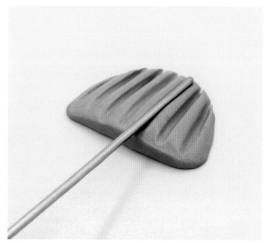

9 Make a half circle piece using gray polymer clay. Press with a stick to create some regular notches.

10 Cut out an arc according to the width of the bookend opening.

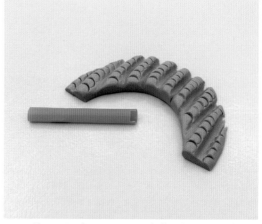

11 Use a pair of scissors to cut a half circle at one end of the straw. Press the straw on the polymer clay piece to form regular horizontal lines.

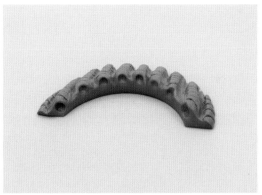

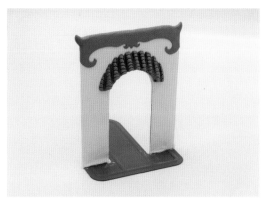

12 Use your fingers to smooth the grooves. These are the tiles. Then put it on a ceramic tile and bake in the oven.

13 Apply a layer of polymer clay glue at the back of the tiles and attach them above the opening. Bake the bookend in the oven. To prevent the tiles from falling when the glue gets dry, set the bookend horizontally.

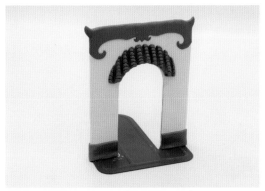

14 Add the bases made of gray polymer clay on the bottom of the wall.

15 Create some brownish and white pellets. These are the stones around the bases.

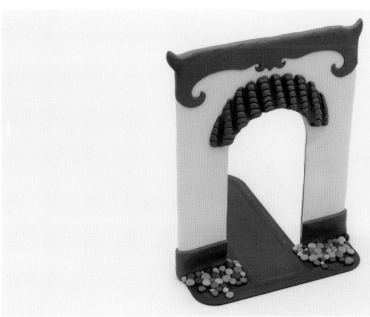

16 Bake in the oven again. The Chinese courtyard bookend is complete.

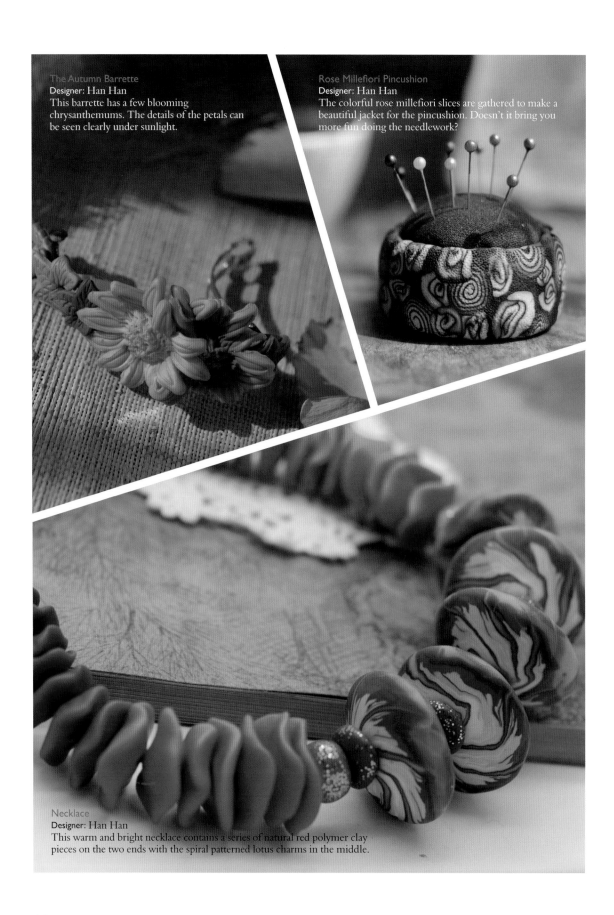

The Autumn Barrette
Designer: Han Han
This barrette has a few blooming chrysanthemums. The details of the petals can be seen clearly under sunlight.

Rose Millefiori Pincushion
Designer: Han Han
The colorful rose millefiori slices are gathered to make a beautiful jacket for the pincushion. Doesn't it bring you more fun doing the needlework?

Necklace
Designer: Han Han
This warm and bright necklace contains a series of natural red polymer clay pieces on the two ends with the spiral patterned lotus charms in the middle.

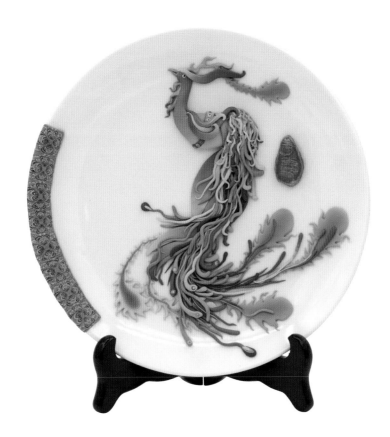

12. Phoenix Plate

In this piece of art, the feathers of the phoenix are illustrated by a combination of fascinating colors. With the white plate as the background, the phoenix becomes more sacred and honorable. You can also add some millefiori slices to decorate the plate.

What You Need

Components	Polymer Clay Colors
Eyespots on upper tail	Green, red, orange, shades of blue, shades of yellow
Train feathers	Rose red, pink, green, red, yellow, orange, shades of purple
Body feathers	Green, pink, purple, shades of blue
Body	Yellow, orange, red
Ribbon	Pink, purple, blue, yellow, green
Crests	Green, pink, purple, shades of blue
Wattles	Pink, purple
Eye	Black, white
Seal	Red
Millefiori slices	Blue, white, brown, yellow, green
Tools: rolling pin, flat tip sculpting tool, rubber tip sculpting tool, long blade	
Supplementary Materials: polymer clay glue, white plate	

1 Rub the blue, light blue and green polymer clay into rods.

2 Use a rolling pin to flatten the 3 strips to form a gradient flat sheet.

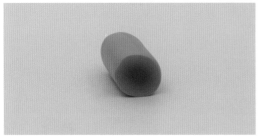

3 Roll up the sheet to form a rod and then slice.

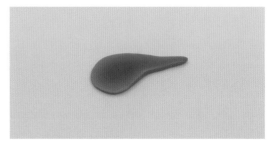

4 Mold the slice into a tadpole shape. This is the eyespot on the upper tail.

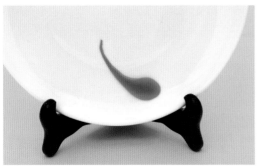

5 Attach the eyespot onto the bottom of the plate using polymer clay glue.

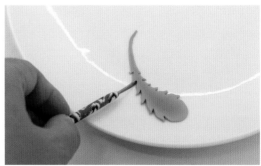

6 Use a flat tip sculpting tool to serrate the edge of the eyespot to enhance the layering effect of the feather.

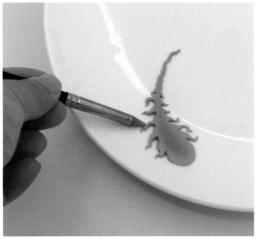

7 Use a rubber tip sculpting tool to adjust the edge so that it looks more natural and smooth.

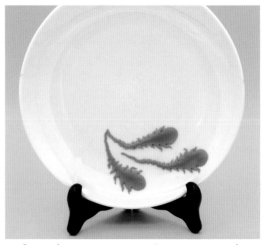

8 Repeat the same steps to create 2 more eyespots and place them at the proper locations.

9 Rub the light yellow, yellow, and red polymer clay into rods.

10 Rub together the 3 strips to form a gradient piece. Roll it up to a rod and then slice.

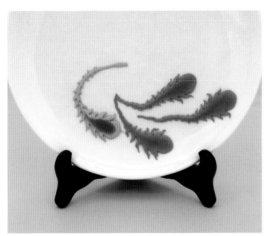

11 Repeat steps 4 to 7 to form an eyespot and properly place it on the plate. Create another eyespot of the same color range for later use.

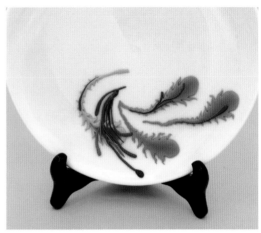

12 Roll some rose red, purple and dark purple polymer clay strips and place them on the plate accordingly. These are the train feathers.

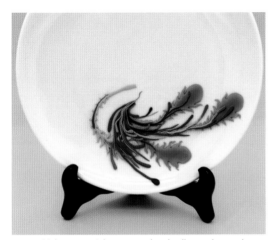

13 Make some pink, green, red and yellow polymer clay strips and place them on the plate as shown. You can also combine 2 colors to create more variations.

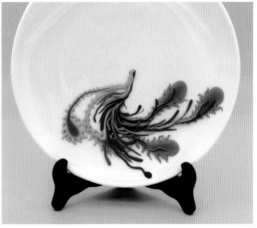

14 Add the eyespot created in step 11 onto the plate accordingly.

15 Make a gradient sheet using the yellow, orange and red polymer clay.

16 Bend the long blade and cut a few crescents out of the gradient sheet. This is the train feather.

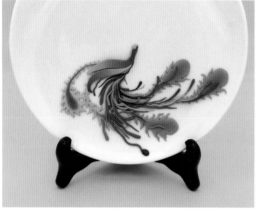

17 Layout the crescents as shown.

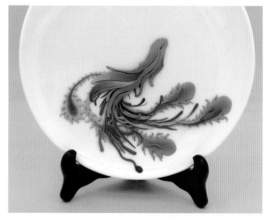

18 Cut several S-shaped pieces in different lengths and widths out from the gradient sheet from step 2. These are the body feathers. Position them accordingly.

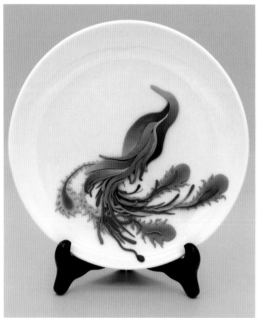

19 Form a gradient sheet using pink and purple polymer clay and cut a few S-shaped pieces in different lengths and widths. These are the body feathers. Apply them on the plate as shown.

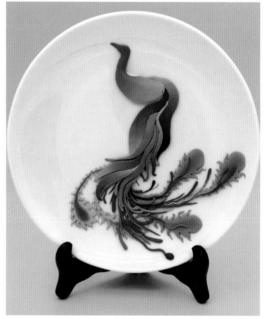

20 Create the phoenix body using the gradient piece from step 15. Note that the body is plump.

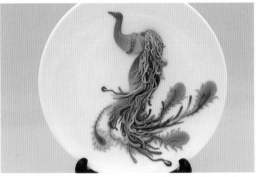

21 Make a number of strips using different polymer clay as the feathers to make the train more colorful.

22 Create the ribbon using the gradient sheet from step 19 to decorate the phoenix body. Add some colorful polymer clay beads on top.

23 Make the crest using the gradient sheet from step 2.

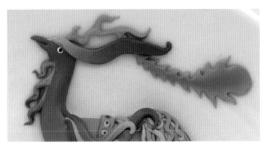

24 Use the black and white polymer clay to form the eye. Create another layer of the crest and wattles using the gradient sheet from step 19.

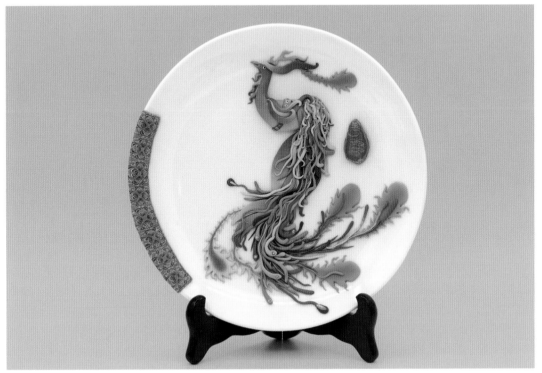

25 The phoenix plate is complete. You can also create another piece with the red polymer clay for your autograph or seal. This is similar to the name seal on the traditional Chinese painting, which allows you to endorse your own art, as well as balance the space. As to the millefiori slices, please refer to the figure on page 9.

CHAPTER FOUR
Advanced Lessons

In Chapter Three, you have learned how to apply the techniques of gradient millefiori, gradient sheet, sculpturing and modeling to the polymer clay crafts. For sure, you have gained a better understanding of this special material. In this chapter, we will get into the more complicated techniques, such as pattern millefiori and color combination. Creativity is our main focus. Let's think outside the box and take a regular everyday item on an entirely new look.

1. Fish Wind Chime

The ancient pattern of fish represents prosperity and luck. Fish in Chinese is a homophone of surplus, delivering a wish of having surplus year after year.

This fish wind chime is quite different from the tradition. The red and yellow body displays the luxuriousness while the colorful fish fins add the cuteness. When the wind arouses the bell attached at the mouth, it sends the blessings to the far.

What You Need

Components	Polymer Clay Colors
Scales	Red, orange, yellow
Dorsal fin, caudal fin, pectoral fin, pelvic fins	White, purple, shades of green, shades of pink, shades of blue, shades of yellow
Cheeks	Red
Eyes	Blue, white, black
Mouth	White
Tools: rolling pin, short blade, flat tip sculpting tool, stick, scissors, ball tip tool	
Supplementary Materials: egg shape mold, round mold, silk cords, bells, split ring, wax cord, tissue	

Facing page
Banquet Table Decor: *The Elixir of Love*
Designer: Han Han
Please refer to the project on page 127 for the steps.

Scales

1 Use the technique of millefiori to create the fish scales. First is to roll up the red polymer clay strip.

2 Form a cylinder.

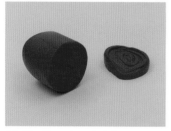

3 Trim the ends so that they are smooth and flat.

4 Cover the red cylinder with orange polymer clay of the same width.

5 Cover the cylinder with yellow polymer clay of the same width.

6 Rub the cylinder back and forth until the 3 different color polymer clay strips are tighten together without any gaps. Trim the ends and the millefiori rod is done.

7 Slice the millefiori and cut the slices into 4 equal sections to make the fan shapes.

Dorsal Fin

1 Use the technique of millefiori to make the dorsal fin. Take out the green, light green and white polymer clay strips.

2 Place the 3 polymer clay strips together to form a gradient flat piece.

3 Cut them into strips of the same width. Stack them up and note that the color transitions in the picture.

4 Press the stack with your thumb and finger.

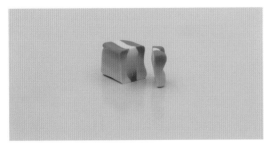

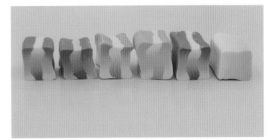

5 Form an irregular cube.

6 Repeat the same steps using the purple, pink, blue and yellow polymer clay strips to make cubes of similar size. Slice them for later use.

Caudal Fin

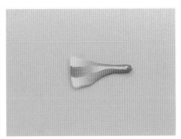

1 Next step is making the caudal fin. Slice the pink cube and press one side to make a fan shape. Rub the other side to shape a round end.

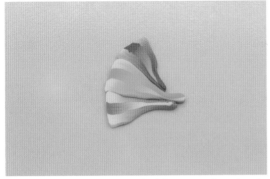

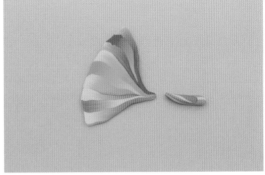

2 Repeat the same steps using the light green and purple polymer clay slices. Arrange them side by side and rub the ends together. Cut out the unneeded portion. Use the same method to create 2 more fan shapes of different color combinations for later use.

Pectoral and Pelvic Fins

1 Press the yellow slice to form 2 fan shapes. They are the pair of pectoral fins.

2 Press the pink, green, purple and blue slices to form 4 fan shapes and arrange them to make a big fan shape. This is the pelvic fin.

Assembling

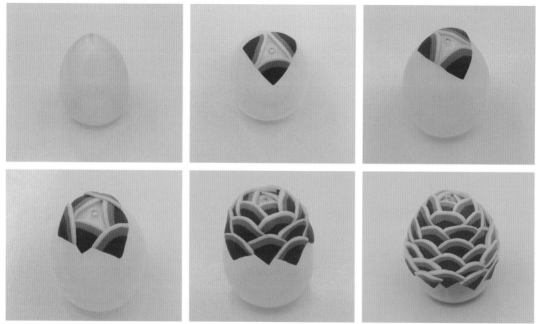

1 Drill a small hole on the top of the heat-resistant egg shape mold for bell hanging. Starting from the top, stagger the scales layer by layer. Note that the arc sides are facing the top whereas the sharp ends are pointing downwards. The second layer to be partially overlaid the previous layer to ensure the egg mold is fully covered.

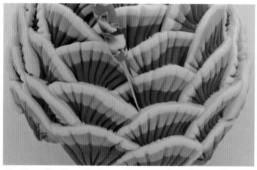

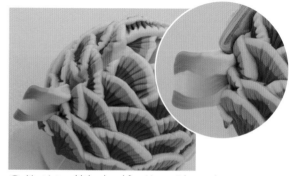

2 Use a flat tip sculpting tool to score the scales in radial direction.

3 Next is to add the dorsal fins. Use a stick to make a groove.

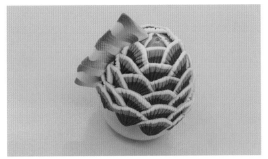

4 Place the colorful millefiori slices into the groove.

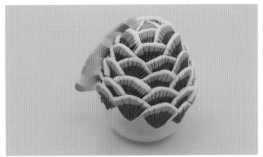

5 Use a pair of scissors to trim the edge to form an arc shape, the lower the wider.

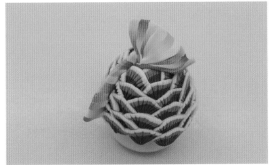

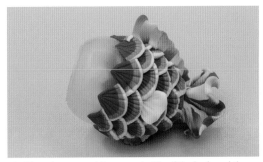

6 Arrange the 3 fan-shaped sets onto the top on the egg mold in the form of morning glory. The caudal fin is done.

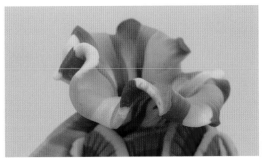

7 Adjust the caudal fin so that it curls naturally.

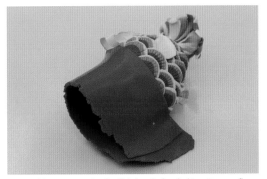

8 Place the pectoral fins on each side of the body and the pelvic fin at the bottom. You can use your fingers to shape the irregular edge.

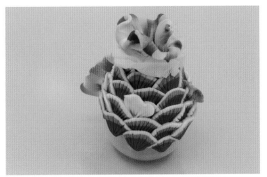

9 Now, it is time to place it in the oven to hold the shape. To avoid the caudal fin being distorted during baking, wrap it around with tissue paper for support.

10 Next is to make the fish head after baking. Form a flat piece using the red polymer clay. Then wrap it around the lower layer of the scales.

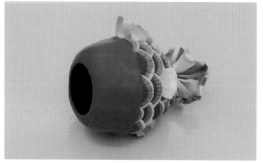

11 Smooth the irregular edge.

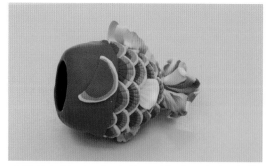

12 Cut a tri-color slice that is used for the scales into half and place it on the right side of the fish eye.

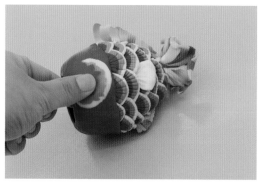

13 Use your thumb to smooth the junction of the slice and fish face, and create a radial effect.

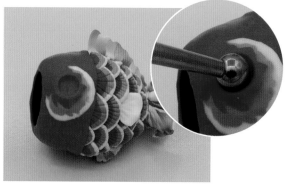

14 Use a ball tip tool to press a small pit at the place of eye.

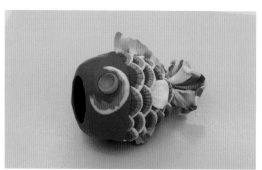

15 Push a piece of blue polymer clay into the pit and use the ball tip tool to create another pit on top.

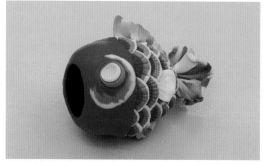

16 Push a piece of white polymer clay into the blue pit.

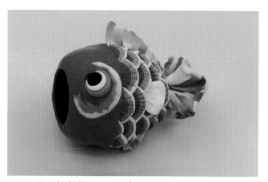

17 Use the ball tip tool to form another pit. Then press a piece of black polymer clay into it.

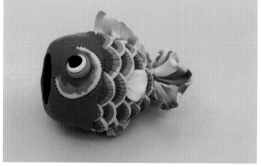

18 Puncture the yellow edge around the eye to create a loop of regular pattern. Then bake the fish in the oven.

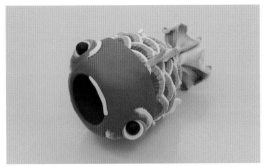

19 Next is to make the mouth. Place a small piece of white polymer clay around the lips.

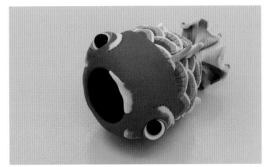

20 Use your thumb to spread the white polymer clay towards the tail to create the irregular gradient effect.

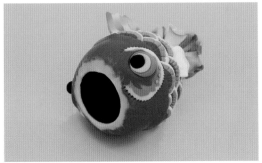

21 Finish the lips by spreading the white polymer clay following step 20.

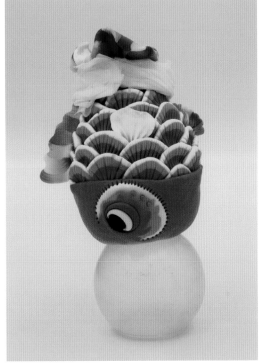

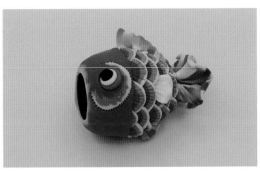

23 The baking process of the fish is finished.

22 Place the fish with the mouth on top of a round heat resistant mold and bake in the oven to avoid distortion.

24 Fasten the bells onto the silk cords of different colors and tie the ends onto a split ring. Attach a wax cord on the other side of the ring.

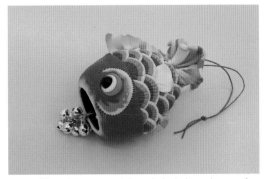

25 Thread the wax cord through the hole on the top of the egg mold and secure with a knot. The wind chime is complete.

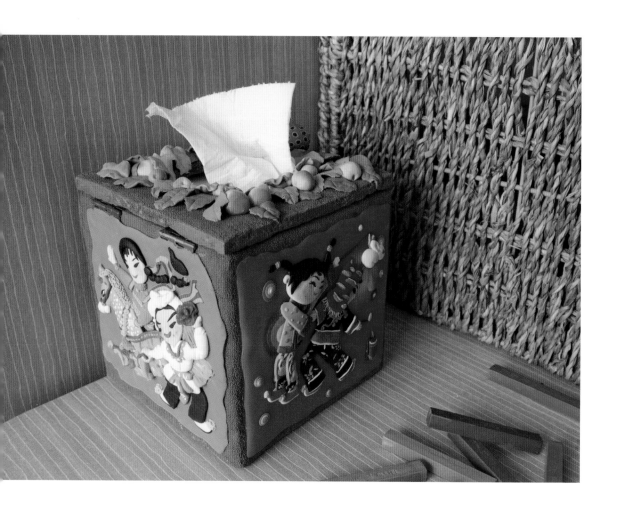

2. Chinese Folk Art Tissue Box

This craft expresses Chinese folk art in prominent colors and lovable characters. You can create your own designs to develop more pictures to decorate your home.

Tissue Box Base

First is to construct a tissue box base before making the polymer clay pictures. You can recycle a paper tissue box or make your own with card boards.

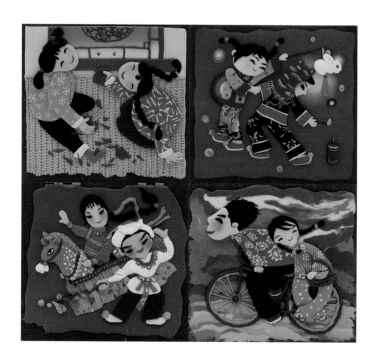

What You Need

Components	Polymer Clay Colors
Box	Purple

Tools: exacto blade

Supplementary Materials: 6 gray card boards (approximately 12 × 12 cm), super glue, aluminum foil, small hinges, polymer clay glue, string

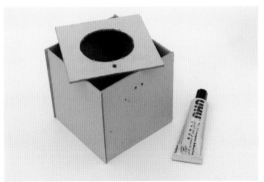

1 Use 5 square gray card boards to produce the tissue box base. You also need a cover that is a little bigger.

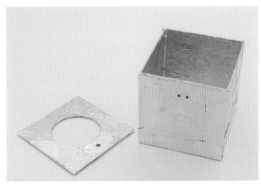

2 Cut a circular opening out of the cover. Pierce a small hole above the opening. Then pierce 2 small holes around the same area on another card board. These holes are for stringing, attaching the cover to the box.

3 Use super glue to adhere the 4 sides to the bottom.

4 Wrap the aluminum foil all around the box and cover.

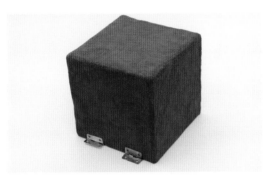

5 Apply a smooth layer of purple polymer clay on the bottom and 4 sides.

6 Attach 2 small hinges on the side that has 2 small holes. You can apply small amount of polymer clay glue to further secure. Use an exacto blade to remove the excessive polymer clay above the box so that it is seamless. Place the box upside down in the oven for baking. The tissue box base is done.

Papercutting

Papercutting is a very common Chinese folk art. It is also called "*chuanghua*," meaning window floral embellishment, since it is a common practice to decorate windows for celebrations and festivals. During Chinese New Year, for example, people like to attach various papercuttings on the windows to enhance the joyful atmosphere. The art of papercutting is a combination of decoration, appreciation, and practicality, providing us a pleasant enjoyment.

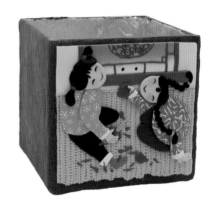

What You Need

Components	Polymer Clay Colors
Wall	Yellow
Sky	White, blue
Mat	Orange
Window and sill	Reddish brown
Papercuttings	Red
Girl in green	Blue, black, green, white, peach, shades of gray, shades of red
Girl in red	Red, white, peach, black, green
Tools: flat tip sculpting tool, rolling pin, exacto blade, scissors	
Supplementary Materials: polymer clay glue, chalk (red)	

Wall, Sky, Mat, Window and Sill

1 Prepare a smooth yellow polymer clay sheet and attach it onto the top. This is the wall.

2 Roll a blue and white gradient polymer clay sheet and attach it onto the top. This is the sky viewing from the window.

3 Next is to make the mat. Rub an orange strip and mark a series of regular notches.

4 Rub another strip and attach it on the side.

5 Again, mark the strip in the opposite direction.

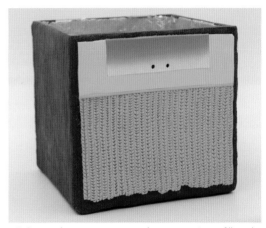

6 Repeat the same steps to produce more strips to fill up the bottom portion of the box. The edge can be irregular so that it looks more natural. The mat is done.

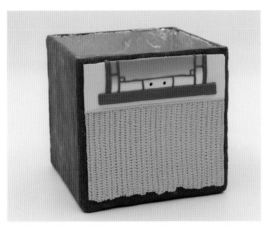

7 Make a few reddish brown clay pieces and attach them around the sky symmetrically. These are the window and sill.

8 Make some small red clay pieces and attach them like papercuttings. Do not limit yourself on the style as long as it roughly presents the image.

Girl in Green

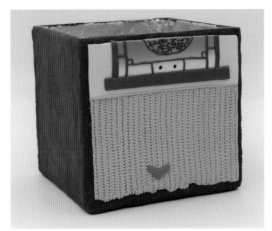

1 Make a blue clay sock and place it on the mat.

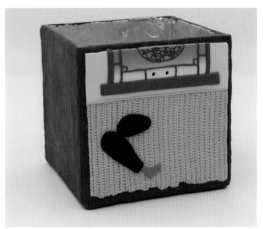

2 Then create a pair of black pants and attach them above the sock.

3 Next is to make the green and white floral blouse. Rub several green and white clay strips and combine them as shown.

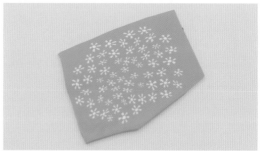

4 Wrap a piece of green clay around them.

5 Rub the combined strips back and forth to form the millefiori rod and slice.

6 Use the same green clay to make a base. Place closely the millefiori slices on top. Rub it with a rolling pin to integrate them.

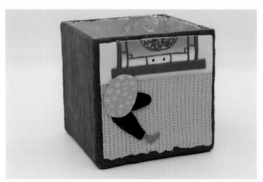

7 Cut an oval shape as the blouse.

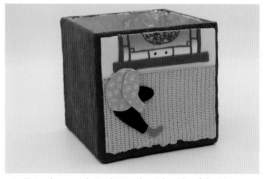

8 Cut a sleeve and attach it to the right side of the blouse.

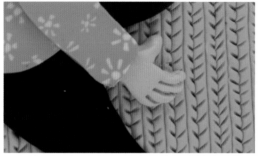

9 Make a hand with the peach clay and attach it below the sleeve. Use an exacto blade to score and shape out the fingers.

10 Make 2 white clay pieces in proper size as the cuffs of the blouse and pants.

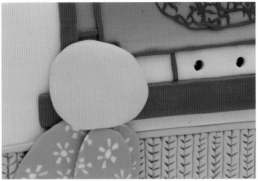

11 Create a peach oval-shaped clay piece as the face.

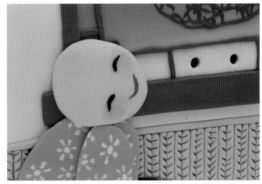

12 Use the red chalk powder as the blush. This is an iconic look for Chinese folk characters. Attach the black clay eyes and red lips.

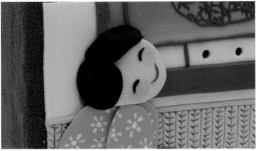

13 Make 2 irregular black clay pieces and attach them on the left. This is the hair.

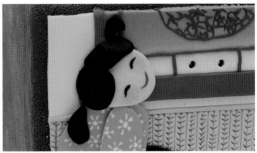

14 Produce 2 black teardrop-shaped clay pieces. Attach the smaller ends to the hair. These are the pigtails.

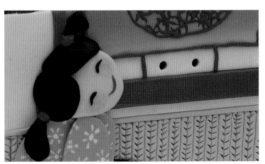

15 Place some small rose red clay pieces between the pigtails and hair. These are the ribbons.

16 Use the dark gray clay to make the handles of the scissors around the fingers.

17 Place the light gray clay strips above the handles and score in the middle.

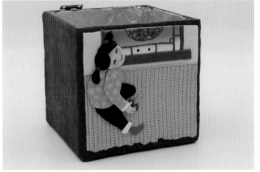

18 The girl in green is complete.

Girl in Red and Papercuttings

1 Refer to the instructions of making the green blouse, use the red and white polymer clay to make a millefiori rod. Slice, layout, and rub to produce a piece of calico with white flowers on red base.

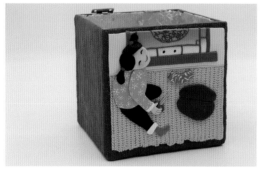 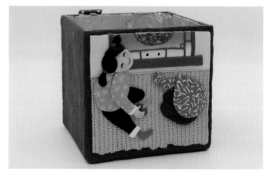

2 Use the black clay to make the pants. Cut a sleeve out of the red and white calico. Place them on the mat as shown.

3 Cut an oval out from the red and white calico as the blouse.

 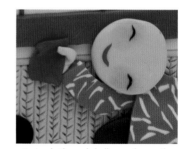

4 Cut another sleeve out from the red and white calico. Make the left hand using the peach clay and use an exacto blade to shape the fingers.

5 Make the right hand using the peach polymer clay. Then place a small red clay piece on the hand. Stretch the edge to form some natural paper creases.

6 Apply the red chalk powder on the cheeks as the blush. Use the black and red polymer clay as the eyes and lips.

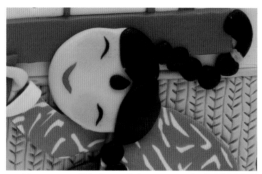

7 Line up several black round clay pieces as the long braid. Use the green clay as the ribbons.

8 Cut a number of red clay pieces and place them on the mat as shown. Bake in the oven to complete.

Firecrackers

Celebrating with firecrackers is one of the customs of Chinese New Year. It usually starts from noon on New Year's Eve until the first day of New Year. The popping noise and fire ignite the joyfulness. The air is full of brightness, like blooming flowers, elevating the festival delight.

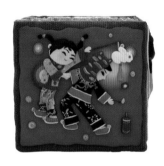

What You Need

Components	Polymer Clay Colors
Background	Red, yellow, orange-red, shades of green, shades of purple, shades of blue
Firecrackers	Yellow, orange-red, brown, black
Boy	Black, white, peach, yellow, shades of blue, shades of orange, shades of green, shades of red, shades of brown
Girl	Red, white, black, blue, peach, orange, dark brown, yellow, pink, shades of green
Rabbit lantern	Brown, white, red, orange
Tools: awl, exacto blade, rolling pin	
Supplementary Materials: polymer clay glue, chalk (red)	

Background

1 Create a gradient sheet using yellow, orange-red and red polymer clay. Roll from the yellow side to form a rod.

2 Roll the rod back and forth until the 3 colors join together. Then slice for later use.

3 Prepare a piece of square polymer clay for the background, using the same red as the gradient rod. Place the gradient slice on the background.

4 Use your fingers to merge it to the background until it is smooth. This is the light from the rabbit lantern that will be produced later.

5 Place the background onto the tissue box with polymer clay glue to strengthen the adhesiveness. Push with your fingers to form the irregular edges.

6 Create a number of different circular clay pieces in different sizes with green, blue and purple colors.

7 Then create a number of smaller circular clay pieces with the shades of green, blue and purple. Put them onto the background as shown.

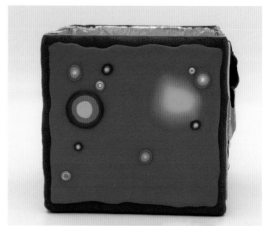

8 They are the random lights to embellish the background.

Firecrackers

1 Create a firecracker with the black polymer clay. Add a piece of brown clay.

2 Refer to the figure, add the yellow and orange-red clay strips as the patterns and flame. The firecracker is done.

Boy

1 Construct the boy from feet to head. First is to prepare the feet with the peach polymer clay. Then overlay 2 blue pieces on top as the shoes.

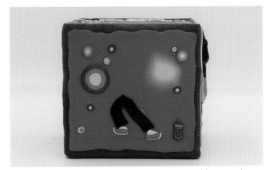

2 Produce 2 black clay pieces as the pants. Add some white strips as the shoe soles.

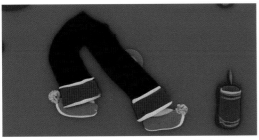

3 Apply some dark blue pieces as the pant cuffs. Add some white strips on the edges as the trims. Mix the yellow and orange clay to produce the fluffy pompoms on the shoes. Use an awl to produce the shaggy effect.

4 Apply some green pieces as the leaves and some red and yellow pieces as the petals to add some patterns on the pants.

5 Make the sleeve with the dark blue clay and the cuff with the blue clay. Add some white strips on the edges as the trims. This is the partially covered arm. Create the hand with the peach clay and use an exacto blade to shape out the fingers.

6 Follow the above step to produce the shirt, the other sleeve and the other hand.

7 Make some branches with the green clay and flowers with the red clay as the plum tree patterns on the shirt. Slit the middle of the flowers to enhance the 3 dimensional effect.

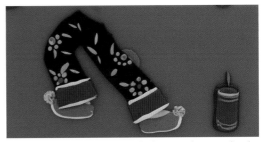

8 Next is to create the head of the boy. Make the face with the features using the peach clay. Apply some red chalk powder onto the cheek as the blush.

9 Create the hair with the black clay. Add some black clay strips around the blush as the eye and eyebrow.

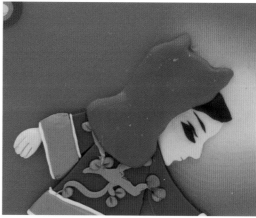

10 Make the tiger hat with the dark red polymer clay.

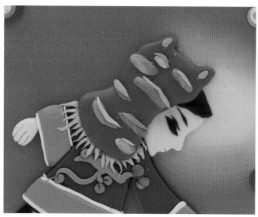

11 Develop the tiger hat patterns with the shades of orange and green clay. Prepare a few orange clay strips as the fuzzy edges of the hat.

12 Prepare a dark brown strip as the match in the boy's hand. Make an orange teardrop as the flame. The boy is complete.

Girl

1 Refer to the instructions of making the boy, construct the shoes and pants for the girl.

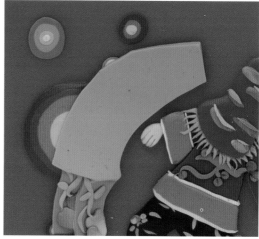

2 Roll a green polymer clay sheet and cut as shown. This is the blouse with one sleeve.

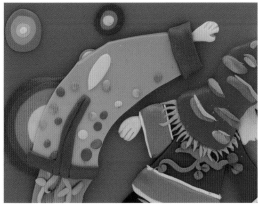

3 Make some yellow, red and orange clay dots and attach them randomly on the blouse. Create some dark green pieces as the cuff and trims. Use the peach clay to produce the neck and hand. Shape out the fingers with an exacto blade.

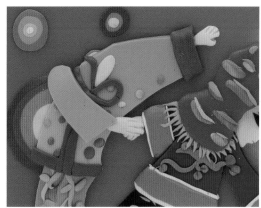

4 Use the green clay to make the other sleeve and the dark green clay to make the collar. Then create the other hand with the peach clay and place it over the boy's hand. Shape out the fingers with an exacto blade.

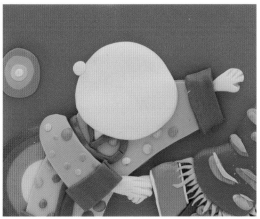

5 Make the girl's head and ear using the peach clay.

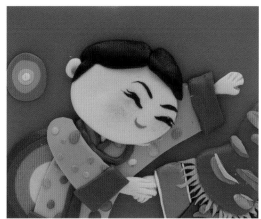

6 Smear some red chalk powder on the cheeks as the blush. Use the black clay to make the smiling eyes, eyebrows and hair. Then apply the red clay strip as the lips.

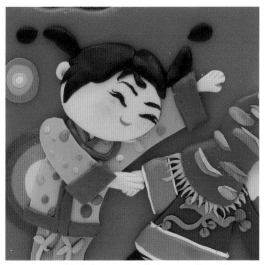

7 Get some black clay to create the bangs and pigtails.

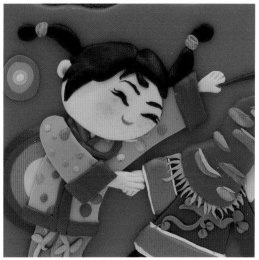

8 Attach some pink clay strips on the pigtails as the ribbons. The girl is set.

Rabbit Lantern

1 Roll a small strip using the brown polymer clay as the holding stick for the rabbit lantern, having it tilted upwards.

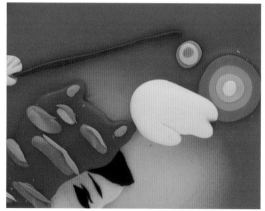

2 Make the rabbit body with the white clay as shown.

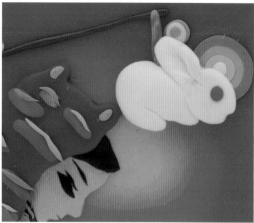

3 Create the rabbit head and ear with the white clay and the eye with the red clay. Roll a gradient strip by mixing the red and orange clay. Place it between the end of the stick and the rabbit. This is the string to connect the lantern to the stick.

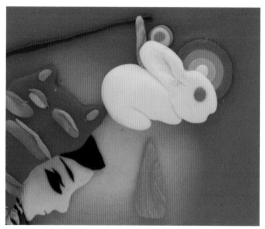

4 Make the triangular tassels with the orange clay.

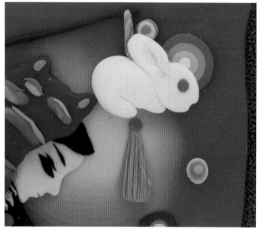

5 Score a few lines to portray the pendulous tassels. Make an orange dot as the knot.

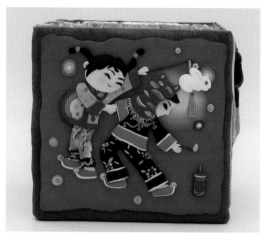

6 Bake it in the oven to complete.

The Land-Boat Dance

The land-boat dance is a popular folk dance all over China. The typical performance is having a woman carrying a bamboo boat with a man next to her rowing with a paddle. They dance like boating on the river in a humorous way. With the joyful music, it creates a lively and exciting atmosphere during Chinese New Year.

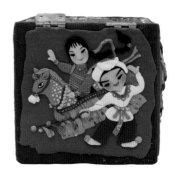

What You Need

Components	Polymer Clay Colors
Background	Grayish blue, black
Woman	Pink, green, peach, orange, red, black
Boat	Purple, white, pink, brown, orange, black, yellow, shades of green, shades of red, shades of blue
Boatman	White, pink, green, peach, red, shades of blue
Horsewhip	Brown, orange, red
Tools: rolling pin, stick, exacto blade, flat tip sculpting tool	
Supplementary Materials: polymer clay glue, chalk (red)	

Background

1 Attach a sheet of grayish blue clay as the background onto the side of the tissue box using polymer clay glue to strengthen the adhesiveness.

2 Make a black diamond clay piece and place it in the middle as the shadow of the boat. The following procedures will be constructed around this diamond.

Woman

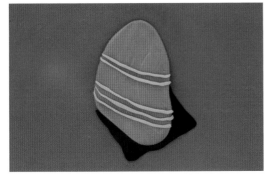

1 Make a pink clay piece as the sweater and some green strips as the patterns. Position them on the background as shown.

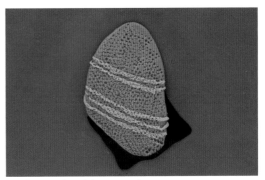

2 Pierce with a stick to create the sweater texture.

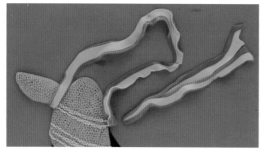

3 Make the arm. Flatten some orange and red strips as the ribbons on the sweater. Use a stick to create some creases to produce the fluttering effect.

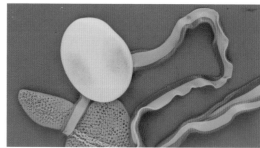

4 Make the head with the peach clay. Tilt it a bit to advance the dynamic effect of dancing. Smear some red chalk powder as the blush.

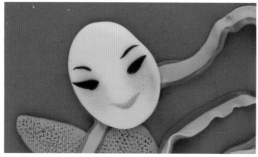

5 Produce the eyes and eyebrows with the black clay and the lips with the red clay.

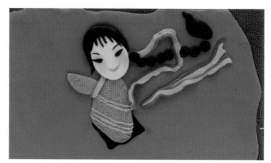

6 Make a black piece as the hair. Roll a few strips as the bangs. Then knead a series of pellets as the braid and arrange it like fluttering in the wind.

Boat

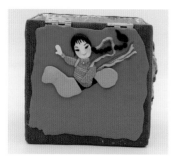

1 Create the front and back of the horse with the purple clay. Make the hand and the other arm.

2 Construct the mane using the light blue clay and attach it onto the horse neck. Then scrape some notches.

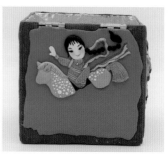

3 Create the ears with the purple clay, the tail with light blue clay, and the spots with white clay.

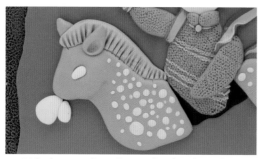

4 Make the eye and muzzle using the white clay as shown.

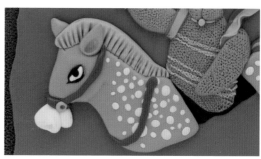

5 Construct the rein with the brown clay and the bit with the orange clay. Finish the eye with the black and white clay.

6 Apply a series of yellow pellets along the rein. Add some red and green pellets for decoration. Create a green trapezoid piece as the satin around the boat. Decorate it with dark red, yellow, white and blue dots. Use a stick to produce some notches as to illustrate the swinging movement.

7 Apply a dark green strip to connect the upper and lower parts of the boat. Place some orange pellets on top for decoration.

8 Mix some yellow, orange and red clay to form a pompom and place it on the horse head. Jab with a stick to uneven the surface to create the shaggy effect. To advance the 3 dimensional result of the mane, likewise use a stick to uneven the top part as shown. Make the hand with the peach clay.

9 Fabricate the tassel on the rein with the pink clay. Use a stick to create some notches to produce the fluttering effect. The woman and the boat are complete.

Boatman

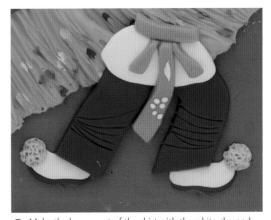

1 Construct the boat man from the bottom to the top. Create the white shoes with the dark blue soles. Make the pants with the dark blue clay piece and use an exacto blade to create the creases. Fabricate the fluffy pompoms on the shoes with the light blue clay. Scrape with a stick to create the shaggy effect.

2 Make the lower part of the shirt with the white clay and the belt with the pink clay. Add some white dots on the belt for decoration.

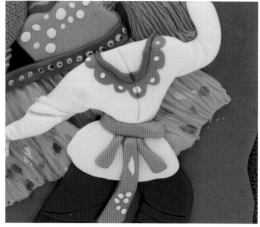

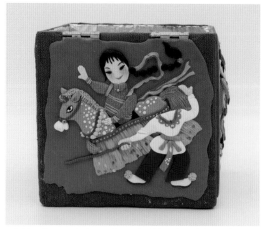

3 Create the upper part of the shirt using the white clay. Fabricate the collar with the light blue and green clay as shown.

4 Use the peach clay to form the 2 hands and shape the fingers with an exacto blade. Make the horsewhip with the brown clay and place it on his hand as shown.

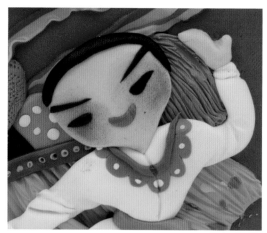

5 Mix the orange and red clay to construct the pompoms and tassels on the horsewhip. Notch them with an exacto blade to create the texture.

6 Make the head with the peach clay, the eyes and eyebrows with the black clay, and the lips with the red clay. Smear some red chalk powder on the cheeks as the blush.

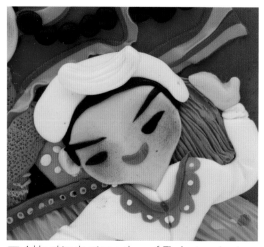

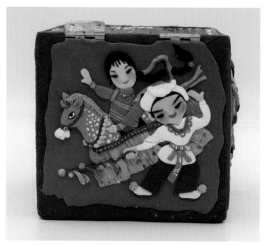

7 Add a white clay piece as the scarf. The boatman is set.

8 Bake in the oven to complete.

Visiting Parents' Home

On the second or third day of Chinese New year, it is very common for the women to go back to their parents' home with their husbands to celebrate. They often bring along some gifts, such as cookies and candies, so that the parents can share some with their friends and relatives, creating a joyous atmosphere.

What You Need

Components	Polymer Clay Colors
Background	White, shades of blue, shades of yellow, shades of green
Bike	Brown, orange, shades of green
Groom	Black, brown, white, red, yellow, orange, peach
Bride	Yellow, white, pink, red, peach, black, shades of brown, shades of green
Tools: scissors, rolling pin, exacto blade	
Supplementary Materials: polymer clay glue, chalk (red)	

Background

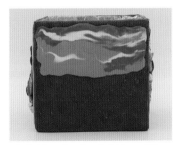

1 Put together the dark blue, white and sky blue polymer clay strips and apply them on the top half of the box. Use your fingers to smear randomly so that the different colors are mixed together and leave no gaps in between. This is the sky.

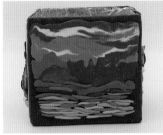

2 Next is to prepare the woods, footpaths, and mountains on the bottom half of the box. Apply randomly the shades of yellow and green clay strips as the footpaths. Then add the shades of green pieces as the mountains.

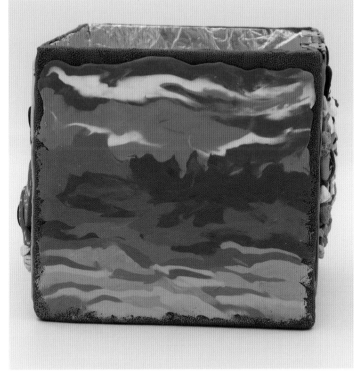

3 Use your fingers to smear the clay pieces so that they are blended together. The background is done.

Groom and Bike

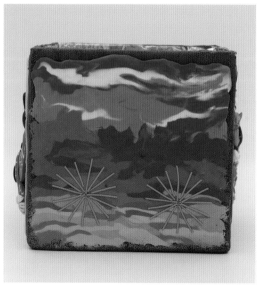

1 First is to make the spokes of the bike. Bake some identical short green strips and arrange them radially as the spokes.

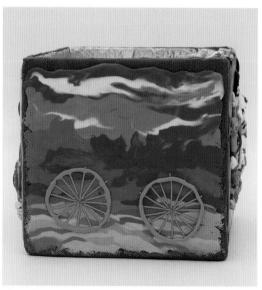

2 Apply a strip around the spokes to form the rim. Be sure there are no gaps in between.

3 Place a brown strip around the rim as the tire. Create some marks on the edge as the tread patterns.

4 Make the groom's pants using the black polymer clay. Then create one of the shoes with the brown clay and the soles with the white clay. Use the brown, dark green and orange clay to form the handlebars and the hubs.

5 Make the frame of the bike with the brown clay and the saddle with the orange clay. The bike is done.

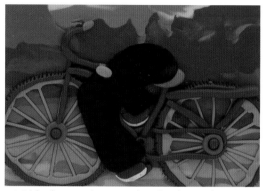

6 Make the groom's pants and another shoe as shown.

7 Use the millefiori technique to make the groom's shirt. Combine the red, yellow and orange clay to form a rod and wrap it with a sheet of yellow clay.

8 Prepare some red and yellow strips and apply them around the rod as shown. Apply a layer of orange clay on top.

9 Rub the millefiori rod back and forth to form the radial pattern. Slice for later use.

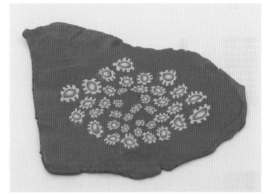

10 Randomly place the slices on a sheet of red clay. Use a rolling pin to rub it until it is flat and smooth.

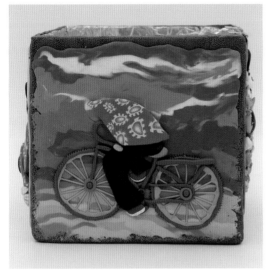

11 Cut a piece to be the shirt as shown in the figure.

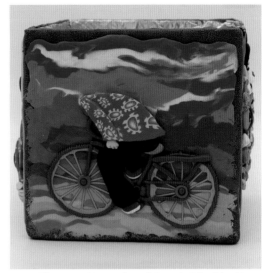

12 Then cut a sleeve and attach it on the left of the shirt and above the handlebar. The bottom of the sleeve is pointing to the handlebar. Use the peach clay to make the hand that holds tight on the handlebar.

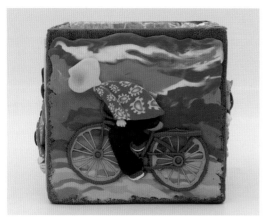

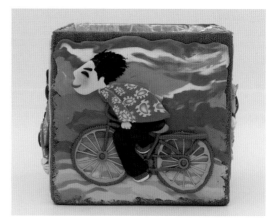

13 Create the head with the peach clay and position it beyond the front wheel with the chin up to present the joyfulness and eagerness of the first time going back home with his bride after the marriage. Smear some red chalk powder as the blush.

14 Make the hair with the black clay and scrape some notches so that it looks like flapping in the wind. Form the eye and eyebrow with the black clay and lips with the red clay. The groom is set.

Bride

1 First is to fabricate the bride's pants and shoes. Roll a long piece of light green clay. Position it on top of the back wheel, overlapping the legs, about the same height as the groom's pants. Place some yellow clay dots on the pants as the patterns. Cut 2 triangular pieces from the clay sheet of the groom's shirt for the bride's shoes.

2 Make the bride's blouse with the pink clay and place it right behind the groom. Apply some white dots as the plum flower patterns.

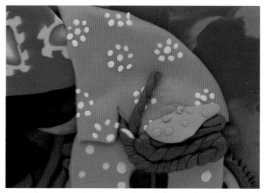

3 Next is to construct the basket that the bride is carrying. Twist the brown and reddish brown clay strips. Loop it to form a basket as shown. Be sure to save a piece for later use.

4 Make a green clay piece with pink dots as the calico over the basket.

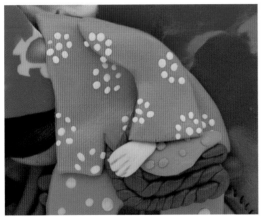

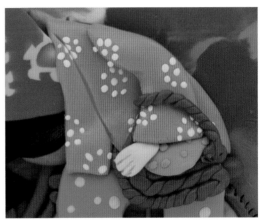

5 Create the sleeve with the pink and white clay and position it as shown. Attach a piece of peach clay below the sleeve as the hand that is holding the basket. Use an exacto blade to shape the fingers.

6 Attach the strip from step 4 as the basket handle.

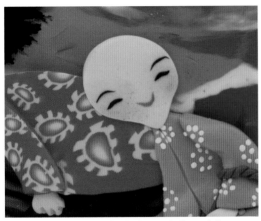

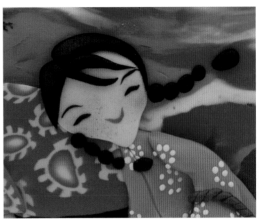

7 Make the bride's head with the peach clay and place it against the back of the groom. Create the eyes and eyebrows using the black clay. Smear some red chalk powder as the blush.

8 Prepare some black pieces, strips and dots for the bride's hair, bangs and braids. The braids are tilted upwards as they are blowing with the wind.

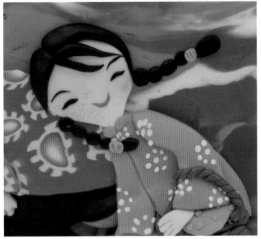

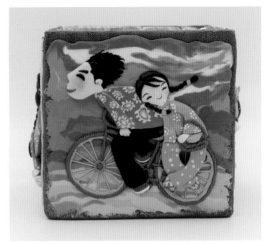

9 Attach some green strips as the ribbons. The artwork is done.

10 Bake it in the oven for setting. Now the 4 sides of the tissue box are complete.

Cover and Assembling

The concepts of the images are based on the Chinese New Year customs and therefore the cover is designed with fruits and leaves to present the good wish for the coming fruitful year.

What You Need

Components	Polymer Clay Colors
Background	Purple
Leaves	Shades of green
Fruits	Red, yellow
Tools: stick	
Supplementary Materials: leaf mold, super glue, string	

1 Prepare a leaf mold.

2 Place a piece of green clay on the tip of a leaf mold.

3 Use your fingers to push it towards the back and 2 sides until it reaches the desired size.

4 Make the indents and textures at the edges.

5 Use your fingers to smooth the indents.

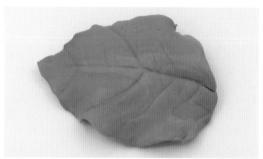

6 Use a stick to curl the edges to make the leaf more natural before placing it on the cover.

7 Apply the purple clay on the cover. Create some pellets in different sizes using a mixture of the red and yellow clay and randomly place them onto the corners of the cover.

8 Arrange the leaf as shown.

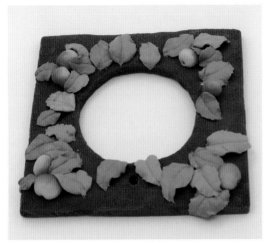

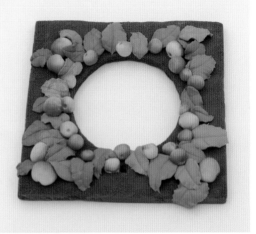

9 Randomly arrange the leaves of different colors and sizes to create a natural feeling.

10 After filling up with the leaves, add some fruits around the opening so that it looks more luxuriant.

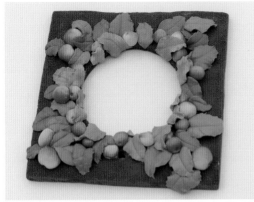

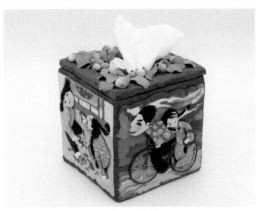

11 Add some smaller and yellower leaves around the opening and make a final adjustment before baking in the oven.

12 Apply some super glue on the hinges to connect the cover to the box. The tissue box is finished. The 2 strings that pass through the holes on the cover and the *Papercutting* side can further secure the cover and make the movement more flexible.

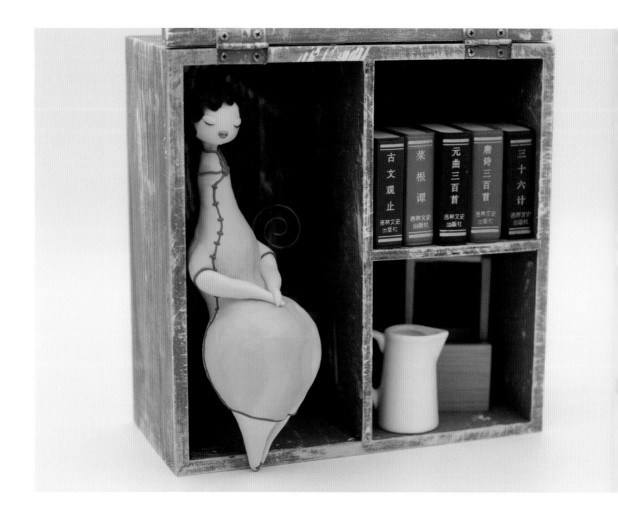

3. The Lady in *Qipao*

Cheongsam (*qipao*) is a traditional Chinese dress popularized in the 1920s. After almost a century of revolution, the contemporary *qipao* shakes off the conservative approach and incorporates different cultures and elements. The styles are more elaborated and designed to promote the beauty of female figure. Nowadays, *qipao* has become the icon of Chinese fashion. Does the woman above look like a fashionable Shanghai lady in the old days taking a break?

What You Need

Components	Polymer Clay Colors
Body	Peach, red, black
Qipao	Red, yellow, shades of green
Arms	Peach
Hair	Black
Tools: rolling pin, long blade, awl	
Supplementary Materials: bottle gourd, toothpick, wire, aluminum foil, chalk (red), super glue, sphere mold	

Body

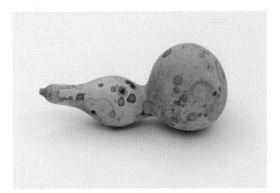

1 Let's utilize the shape of the bottle gourd, two rounded ends with slim middle, to mimic a lady figure and use polymer clay to revive an old item. You can see that the shaper end is like the head while the bulky end is like the lower part of a body.

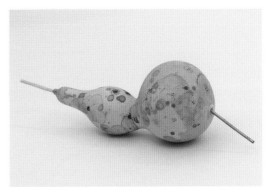

2 Attach a toothpick to the head and a wire to the bottom. The toothpick is used to extend the neck and the wire is used as the base of the legs.

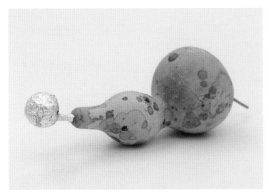

3 Place a sphere mold on the toothpick. Wrap both the mold and toothpick with aluminum foil. The sphere is the head.

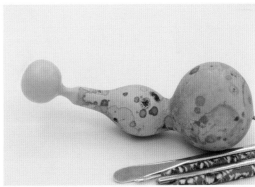

4 Apply a layer of peach polymer clay on the head and neck.

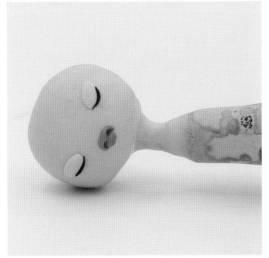

5 Make 2 oval shaped polymer clay pieces as the eyelids and 2 black clay strips as the eyelines to form the girl's humble face. Attach 2 red clay pieces and curl the middle to form the lips. Then bake it in the oven to cure the head and neck.

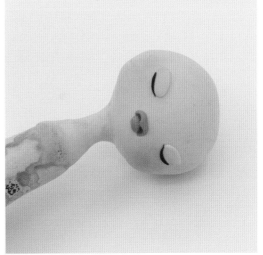

6 After a quick baking, apply a layer of red chalk powder on the cheeks as the blush. The trick is to apply the powder after baking so that it looks more natural.

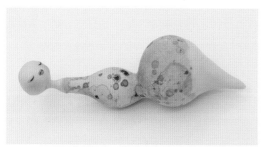

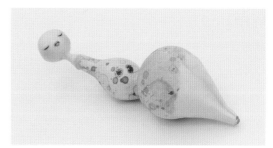

7 Apply the peach clay starting from the biggest part of the bottle gourd towards the wire to form a cone shape. This is the leg portion.

8 Score the middle to outline the legs. Add a small piece of red clay as the pair of elegant red high heels.

Qipao and Arms

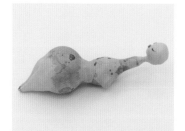

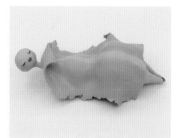

1 Mix the yellow, lawn green, army green and grayish green polymer clay to form a gradient sheet.

2 If the middle of the bottle gourd is too slim, place a small amount of clay from step 1 to enlarge the waist. As shown on the picture, add some clay to form the shoulders.

3 Put the gradient sheet on the front side of the bottle gourd. You can see the color transitions.

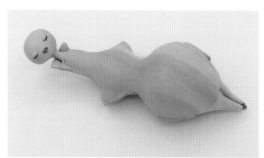

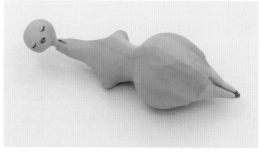

4 Place another clay sheet at the back.

5 Trim the edges and rub to even out.

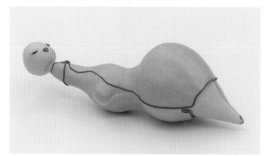

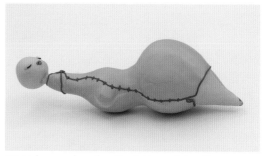

6 Add the red strips to mimic the trims of the qipao.

7 Make a number of small red strips and place them perpendicularly along the red strips produced in the previous step as the knot buttons.

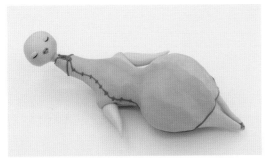

8 Create 2 arms and attach them below the shoulders.

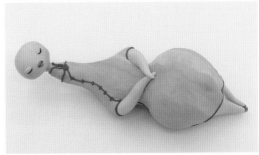

9 Cross the arms like a lady. The gestures of the arms and legs are to be consistent.

Hair

1 Make 1 small and 1 big teardrops using the black clay.

2 Score with a blade or the tip of other tool to generate the hair.

Assembling

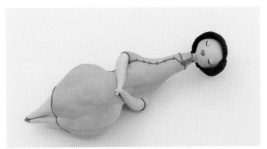

1 Attach the hair to the 2 sides of the head.

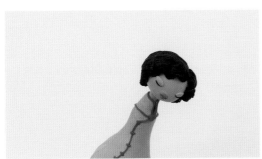

2 Use an awl to shape the edges to create the wave effect. This is the popular hair style in the 1930s.

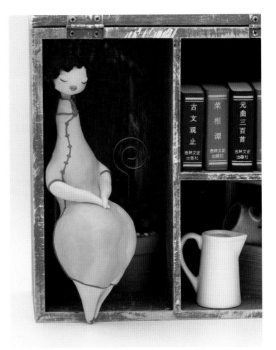

3 Bake in the oven to cure. This lady is not able to stand up by herself. She needs to lean against a vertical surface.

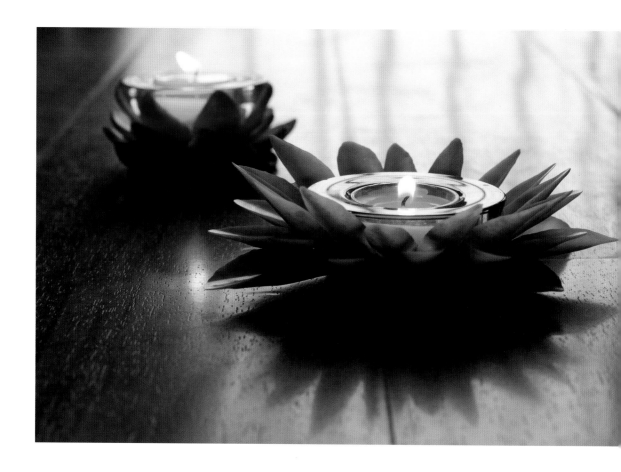

4. Lotus Candle Holder

The lotus is the symbol of gentleman in Chinese traditional culture. One of the famous poems describes it as "growing out of the mud but inheriting no dirt; being cleansed with water but showing no coquettishness." It represents faithfulness and purity. Its elegant nature makes it the feature element of a lot of paintings.

In this art piece, we use the polymer clay to form the petals and combine them with a candle holder. At night, the candle flame flickers among the petals, creating a scene of romance.

What You Need

Components	Polymer Clay Colors
Petals	Translucent white
Stamens	Pink
Base	Brown

Tools: rolling pin, paint brush, awl

Supplementary Materials: chalks (dark blue, light blue, pink), glass candle holder, instant adhesive, super glue

Petals

1 Rub the translucent white polymer clay into spindle shape.

2 Press it onto a stainless steel rolling pin.

3 Use your fingers to push the (petal) ends to the center until the middle portion projects out and the edges are thinner.

4 Scrape the dark blue, light blue and pink chalks. Dip the paint brush into the light and dark blue chalk powder and apply on the sides of the petal. Then brush the pink chalk powder onto the tip of the petal.

5 Create a number of petals in various sizes and place them on the stainless steel rolling pin of different sizes. This helps to hold the shapes and creates a full layering effect. Bake them in the oven.

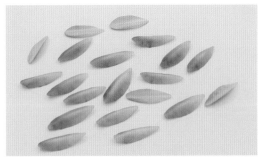

6 Remove the petals from the rolling pin.

Stamens and Base

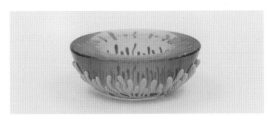

1 Create a number of pink tadpole-shaped pieces as the stamens and place them around the bottom of the glass candle holder.

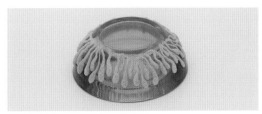

2 Use a toothpick or an awl to poke the stamens to create an unsmooth surface. Bake in the oven.

Assembling

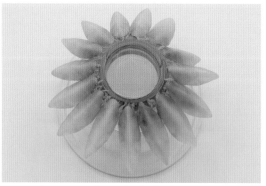

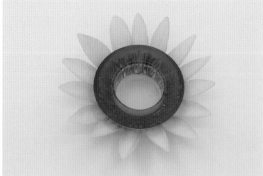

1 Now let's arrange the petals. The first layer is the smallest among the three. First, apply the instant adhesive onto the bottom of the petal and attach it onto the bottom of the candle holder. The instant adhesive reacts quickly but the adhesiveness lowers as time passes by. This is the reason why you then need to apply the super glue onto the bottom of the petal. It is more heat- and corrosion-resistant. The left picture is the bottom view and the right picture is the top view.

2 When the super glue dries after a few hours, place the second layer of petals following step 1. Repeat step 1 to form the third layer, which consists of the largest petals. Note that you have to wait for the super glue to dry completely before the next step.

3 Make a round base with the brown polymer clay. Bake and then attach it onto the bottom using super glue. You can place something heavy on top so that the base and the petals can be more tightly bonded.

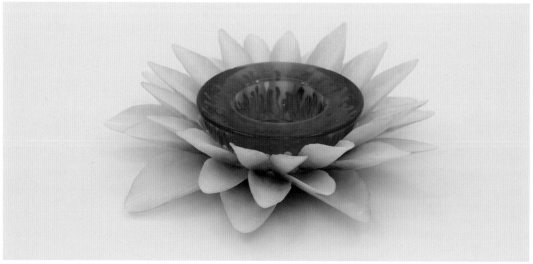

4 The lotus candle holder is complete.

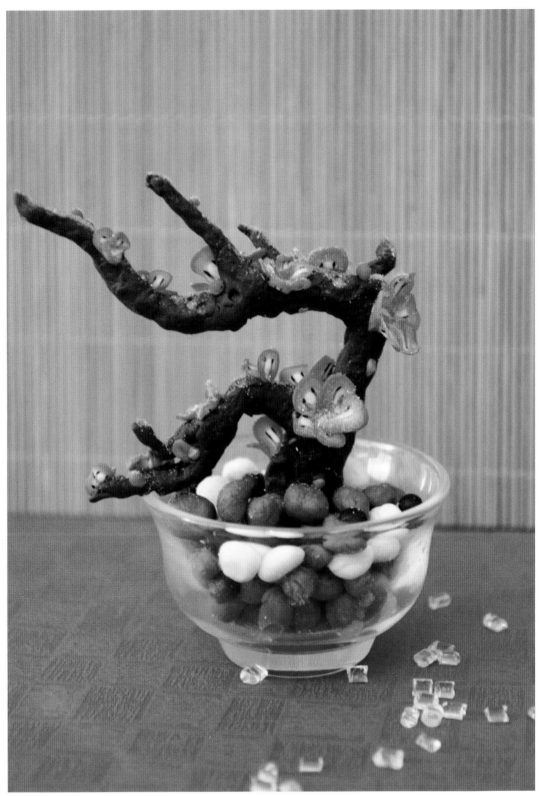

Potted Plum Blossoms
Designer: Jiang Shan
The scene of plum blossoms in snow is one of the most popular themes for the poets.

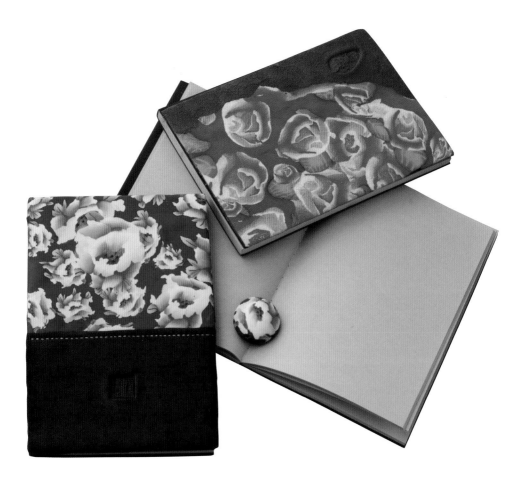

5. Floral Notebook Cover

This notebook cover, with a natural and bright style, makes the plain notebook very colorful. The floral pattern is based on the distinctive shape of peony, symbolizing prosperity.

The technique of millefiori, combines various polymer clay strips of different colors, producing a mixed and colorful effect. None of the monotone polymer clay can compete with it. You can put forth your creativity to design the floral patterns to the greatest diversity.

What You Need

Components	Polymer Clay Colors
Flowers	White, pink, magenta, red, black
Leaves	Yellow, green, jade
Base	Blue, black
Stitches	Rose red
Tools: short balde, roller, rolling pin	
Supplementary Materials: plastic wrap, super glue	

Flowers

1 Stack the white, pink, magenta and red polymer clay, and roll them in one direction to form a gradient flat piece.

2 Cut the piece into equal strips.

3 Stack the strips and they can be shifted a bit to create a loose and layering effect by having the color transitions at different locations.

4 Press slowly the stack between your thumb and finger to tighten and reduce the size.

5 They can be in cube or cylinder form.

6 Produce more cylinder pieces of different colors and gradients according to your design.

7 Place some thin red and black polymer clay strips on the side of the light color cylinder piece as the pistil.

8 Put some white thin polymer clay strips above the red strips. The core part is set.

9 Add randomly the red-white gradient cube and cylinder pieces by referring to the end product.

Leaves

1 Form several yellow-green gradient polymer clay cylinder pieces. These are the leaves.

2 Cut one of the pieces in half.

3 Place a jade piece in the middle as the stem.

4 Press the pieces from step 3 to form long or flat leaves.

Assembling

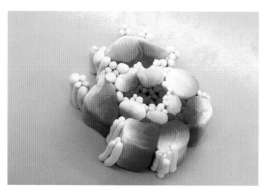

1 Arrange the flowers.

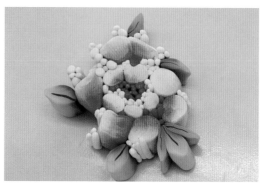

2 Arrange the leaves.

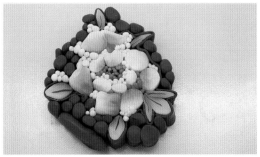

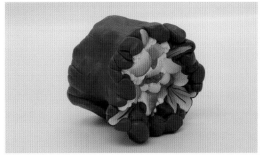

3 Add some blue polymer clay pieces around the flowers and leaves. An irregular floral piece is formed.

4 Knead, press and roll, starting from the middle of the piece towards the ends.

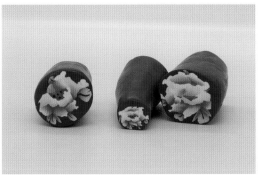

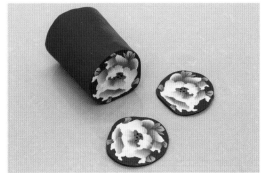

5 Now you have create a long and thin piece.

6 Trim both ends and you can see the floral pattern in the middle. A millefiori rod is set.

7 Cut the millefiori rod into a few sections. Keep rolling the sections into different sizes for later use.

8 If the polymer clay is too soft, the slices cannot be kept in a good shape and the pattern may be damaged. Wrap around with plastic wrap and place them into the freezer until it is stiff. This can make the slicing process a lot easier and neat.

9 Roll a piece of flat and smooth blue polymer clay as the base on a ceramic tile. Be sure it is the same color as the blue in the millefiori rod.

10 Place the floral slices of different sizes on the blue base. You can also trim off the blue portion of the millefiori slices and keep the red flowers and green leaves, then put them on the blue base. The overlapping of flowers makes the scene more lifelike.

11 Place a piece of plastic wrap on top and flatten it with a roller. While rolling, ensure the pressure on the piece is even to keep the floral patterns in its form and the polymer clay is not too soft to distort the design. Then remove the plastic wrap and roll once more to further flatten and integrate the flowers and blue base.

12 Keep rolling with the rolling pin until it is flat and smooth.

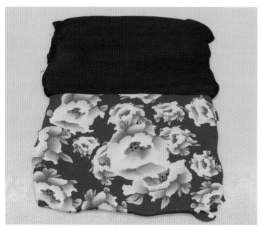

13 Roll a piece of black polymer clay. Connect it with the floral piece.

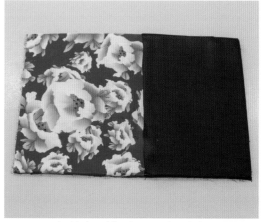

14 Trim the black and floral pieces. The whole piece is to be a bit bigger than the notebook.

15 Rub a thin rose red strip and bake it in the oven. Cut it into equal dots.

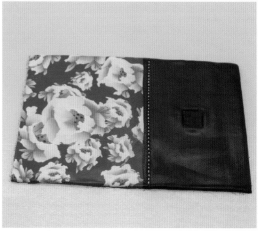

16 As shown in the picture, embed the dots into the seams between the black and floral pieces to mimic the stitch effect. The notebook cover is done. Bake it in the oven to harden it. Remove it from the ceramic tile after cooling and apply it on the notebook using super glue.

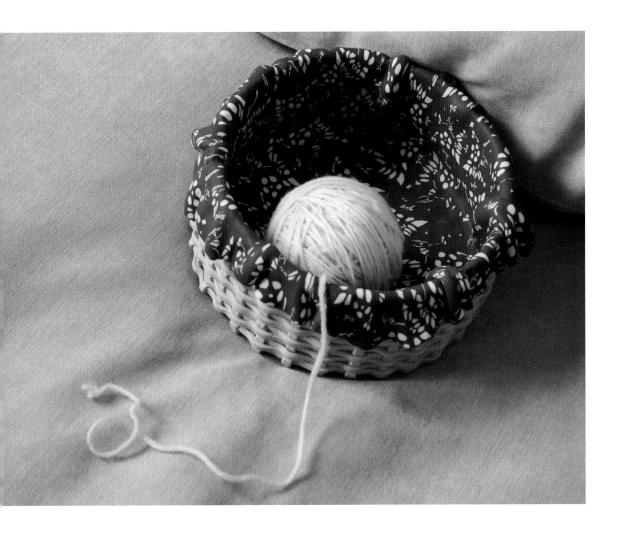

6. Blue Calico Basket

The blue calico uses a traditional Chinese dyeing technique dated back to 1300 years ago. There are two main styles: blue flowers on white fabric and white flowers on blue fabric. The simple and basic "blue and white" create a pure, natural and graceful art style. The blue patterns include animals, plants, and auspicious motifs, which represent the wish for happy life.

In this piece of art, the blue calico is made of polymer clay that looks strikingly true to life. Not only does it look beautiful but also provides practicality.

What You Need

Components	Polymer Clay Colors
Calico	White, blue
Basket	Yellow
Tools: rolling pin, stick, long blade, roller, scissors	
Supplementary Materials: round container, aluminum foil, plastic wrap, polymer clay glue	

Calico

1 Roll the white polymer clay to a rod and wrap it with a blue polymer clay sheet.

2 Rub the blue and white rod until it is long and narrow.

3 Cut the blue and white rod into 6 equal portions. Further rub one of them to a longer and narrower rod.

4 Wrap another layer of blue polymer clay around the narrower rod.

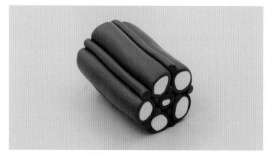

5 Make another 5 blue narrow strips. Set together the 5 blue and white rods, 5 blue narrow strips, and the narrow blue and white rod from step 4 like a flower.

6 Prepare 5 more blue narrow strips and place them among the rods as shown.

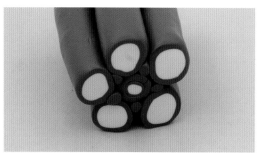

7 Roll a sheet of blue polymer clay and wrap it around to form the outer layer. The flower is set.

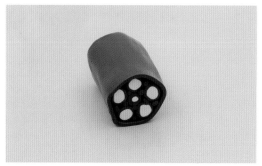

8 Next is to make the leaves. Create the blue and white rod again. Press one side to make a teardrop.

9 Cut the strip into equal portions and put them together.

10 Or make 3 narrow blue strips and place them among 3 teardrop rods.

11 You can also press the rods to form a half circle.

12 Cut and attach them together.

13 You can also use a roller to rub the blue and white rod to turn it to rectangular shape. Use your creativity to form different shapes for the leaves.

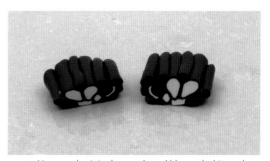

14 You can also join the pre-shaped blue and white rods with the blue strips as shown.

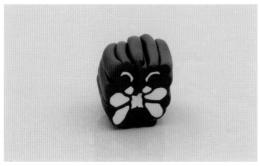

15 Assemble the two polymer clay together.

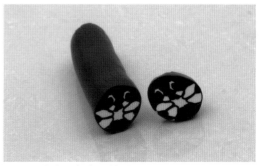

16 Rub them back and forth to create a new pattern. This method can produce more profiles.

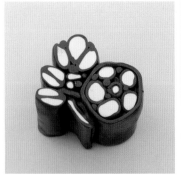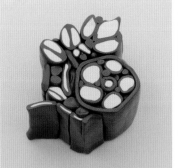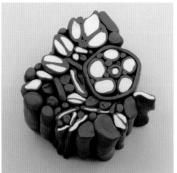

17 Arrange together the flowers and leaves of different shapes. Add some blue strips of different sizes to the gaps.

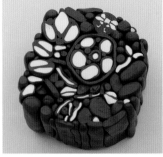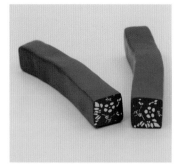

18 Continue to add more clay strips to elaborate the flower and leaf pattern as shown.

19 Rub the polymer clay until it becomes a square shape.

20 Be sure to rub gently from the center towards the ends. Do not stretch at once, otherwise the profile will be distorted.

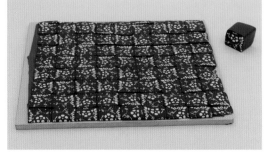

21 Make a sheet of blue polymer clay.

22 Slice the millefiori rod and assemble the calico on the blue sheet of step 21 according to the desired size.

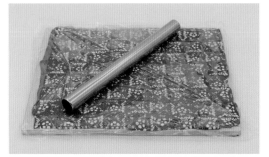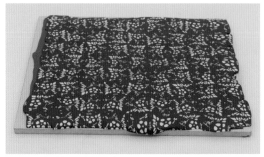

23 Place a piece of plastic wrap on top and use a rolling pin to rub until the gaps are clear.

24 The blue calico is done.

Basket

1 Wrap the aluminum foil around a round container.

2 Make a sheet of yellow polymer clay and use the long blade to cut some identical strips.

3 Place radially 4 strips on the base of the container, intersecting at the center.

4 Rotate the container 90 degree. Place another 4 strips same as step 3. All the 8 strips are arranged radially in equal spacing.

5 Take another strip and pass it under and over the radial strips to form a circle. Use a stick to press the strips that are underneath to produce the weaving effect, as well as to secure the strips to avoid the strips above being too high up.

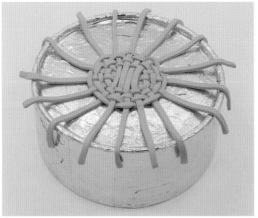

6 Repeat the same steps to expand the weaving from the center.

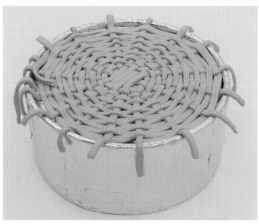

7 The basket base is set.

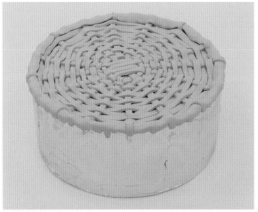

8 Make a wide and thin strip to wrap around the rim of the container. Then bake in the oven.

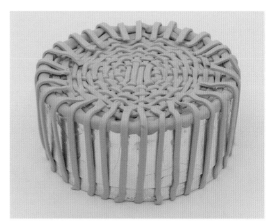

9 Next is to construct the basket weaving on the side. To make the interlacing continuous, connect 16 strips to the 16 radial strips from the base. Then add a strip between every 2 strips.

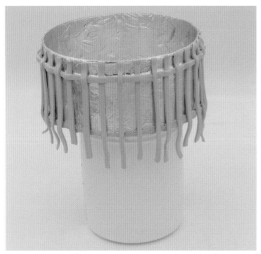

10 Flip over the container. Take a strip horizontally passing it under and over the vertical strips. Use polymer clay glue for setting.

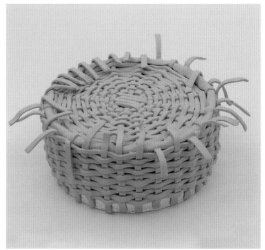

11 The side of the basket is done.

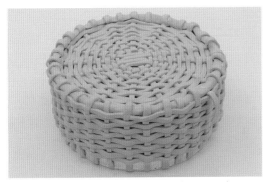

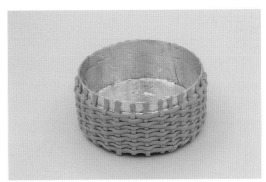

12 The excessive portion of the vertical strips can be flipped over. Some areas may require polymer clay glue to increase the durability.

13 Bake in the oven for setting.

Assembling

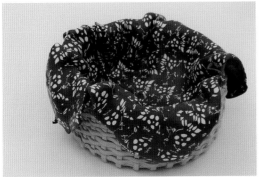

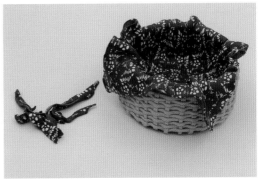

1 Place the blue calico on the basket. Do not expose the aluminum foil on the container.

2 Trim the calico. Press it to the side and base of the basket. Be sure to do it gently to create natural creases.

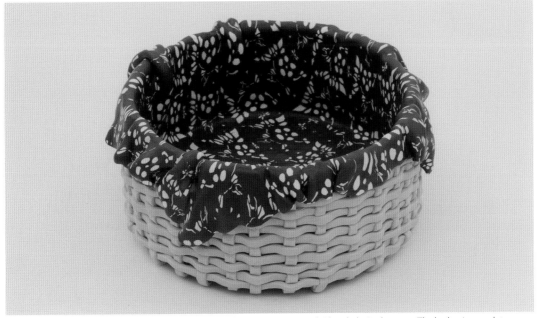

3 Use a pair of scissors to trim the calico so that the edges are more natural. Then bake in the oven. The basket is complete.

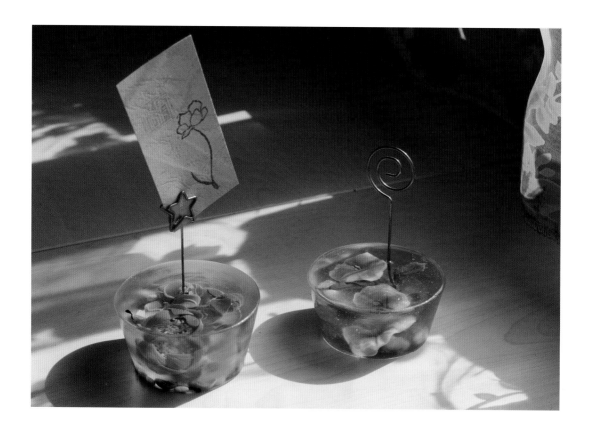

7. Lotus Place Card Holder

The blooming lotus floating on the pond giving out a light fragrance is a very refreshing scene. In Chinese literature, lotus has a unique and pure personality, no matter it is newborn or withered.

This place card holder sets the lotus flowers and leaf in a piece of clear epoxy like capturing the best moment of the lotus. After learning this lesson, you can use the same method to capture the best moment you think.

What You Need

Components	Polymer Clay Colors
Stamens	Orange, shades of yellow
Seed pod	Shades of green
Petals	Pink, rose red
Leaf	Shades of green
Pebbles	Shades of brown
Tadpoles	Black

Tools: pliers, long blade, awl, heat gun, ball tip tool

Supplementary Materials: cardholder, aluminum foil, toothpick, tissue, silicon mold, stainless steel hemisphere mold, clear epoxy, sandpaper

Stamens, Seed Pod and Petals

1 Prepare a pellet using the light yellow clay. Place a yellow piece on top. Then attach a small orange pellet.

2 Rub them together to form a bigger pellet. The order of colors remains the same.

3 Rub it to a tapered rod. This is the stamen.

4 Create a number of small pellets using the green clay. These are for the seed pod. Place the stamens and green pellets on a ceramic tile and bake in the oven.

5 Next is to make the petals. Roll the gradient piece made of pink and rose red clay. Rub to form an even clay rod.

6 Slice and cut it into 4 equal sections.

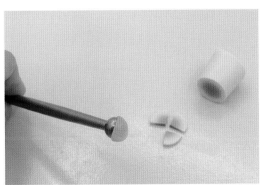

7 Use a ball tip tool to curl the petal.

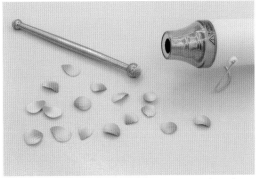

8 Create a number of petals. Use an awl to score from the tip radially. Cure with a heat gun.

9 Bend the end of the place card holder 90° using a pair of pliers so that it does not fall out from the epoxy.

10 Tie a toothpick to the bended end and wrap it with some aluminum foil.

11 Wrap the green clay around the aluminum foil and the tip of the toothpick exposed.

12 Place a yellowish green clay pellet on the tip of the toothpick and mold it like a seed pod.

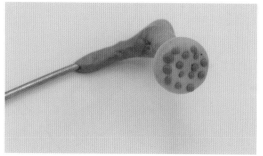

13 Add the green pellets to form the seed pod.

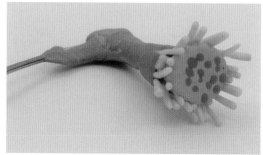

14 Attach the stamens around the seed pod with the round tips on top. Wrap the lower part of the stamens with green clay.

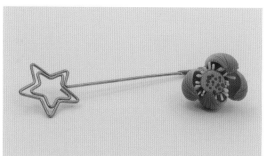

15 Overlap the petals around the stamens. The left picture shows the top view and the right picture presents the side view.

16 Continue to add more petals. Secure the petals by wrapping the bottom part with the green clay. The lotus is done.

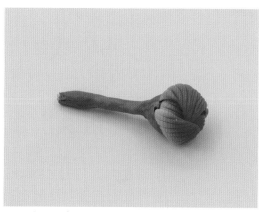

17 Repeat the steps to produce a lotus bud.

Leaf

1 Make the lotus leaf with various shades of green clay.

2 Form the clay rod with lighter green around the darker green clay.

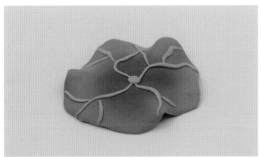

3 Slice and press to form irregular edge.

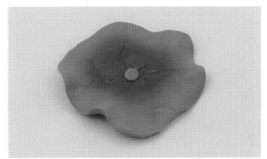

4 Use your finger tips to curl the edge so that it looks natural.

5 Use yellowish green clay to make the veins. Curve and place them on the leaf. Pay attention to the flow of the veins.

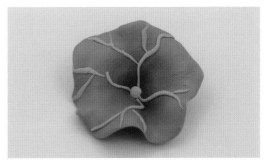

6 Further curl the leave so that it is more three dimensional. The leaf is set.

Pebbles and Tadpoles

1 Make a number of pellets using various shades of brown clay as the pebbles under the river.

2 Create a few tadpoles using the black clay. Note that the tadpole tails are curled like swinging during swimming.

Assembling

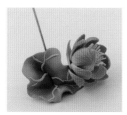

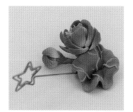

1 Arrange the lotus flower and leaf on the place card holder as shown.

2 Add the bud as shown.

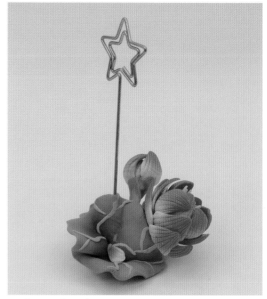

3 Wrap some tissue around the lotus arrangement and place it in a stainless steel hemisphere mold. Bake in the oven.

4 Remove from the oven.

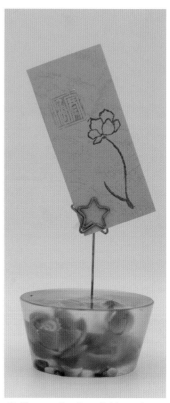

5 Put the pebbles into a silicon mold.

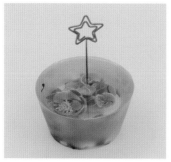

6 Put the lotus and tadpoles into the silicon mold. Pour in the clear epoxy (with ratio of 3:1). Let it sit for 3 days or until it is cured. Remove it from the mold.

7 Smooth the side with a piece of sandpaper. It looks like sandblasted after removing from the mold.

8 If you prefer glossy finish, apply a layer of epoxy around and let it dry.

8. Banquet Table Decor: *The Elixir of Love*

The "elixir of love" (*hua hao yue yuan*) is a perfect romantic scene for newlyweds. In this piece of art, the yellow circle represents the full moon, the rock portrays the love as solid as a rock, and the four little birds displays the perfect harmony. The word "double-happiness" (*xi*, 囍) on the rock magnifies the joyfulness.

This art can be used as a banquet table number or home decoration. It is worth to mention the number of the birds matches the table number. Of course, you can simply modify the table number for your occasion.

What You Need

Components	Polymer Clay Colors
Moon	Yellow
Branch	Shades of brown
Rocks	Silver
Birds	Orange, white, yellow, shades of green, shades of blue
Moss	Shades of green
Double-Happiness	Red
Table Number	Light green

Tools: stick, exacto blade, short blade

Supplementary Materials: circular mold, aluminum foil, wire, mica powder (black and pearl), chalks (orange, blue, green), heat-resistant glossy beads, glitters (gold), heart and circular molds

Moon and Branch

1 Prepare a circular mold. This one is made by cardboard. You can also use the double-sided tape core or other alternatives.

2 Fully wrap the mold with aluminum foil for shaping the polymer clay.

3 Apply the wire on the upper portion of the circular mold according to the shape of the branch.

4 Turn the mold upside down and fully wrap the wire with aluminum foil.

5 Place the yellow polymer clay along the inner side and the edge of the circular mold.

6 Apply the pearl mica powder on the yellow polymer clay as a glossy layer. Then bake it in the oven.

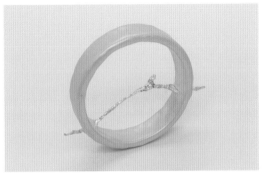

7 After baking and when it cools down, repeat steps 5 and 6 along the outer side, and bake again.

8 Make the branch with light, medium and dark brown polymer clay.

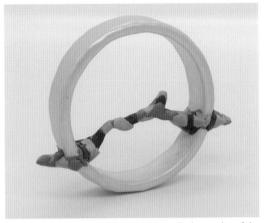

9 Wrap the clay around the wire. This is the base color of the branch.

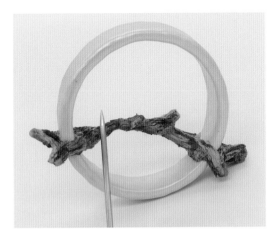

10 Use a stick to score lines in different lengths on the branch and smooth the surface to produce a mixture of speckled and even result like a tree bark. During the process, you can continue to add the mixed color polymer clay on the branch to generate a lifelike effect.

Birds

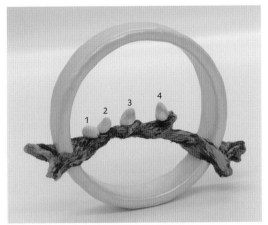

1 Next is to make the birds. Knead the white and blue polymer clay to create 4 egg-shaped pieces and place them on the branch. The base of the birds is set. Number the birds from left to right as 1, 2, 3 and 4. Pay attention to the distance between and the posture of the birds. Then bake in the oven.

2 Now let's decorate the birds. We will use bird 4 for demonstration. Apply a layer of basic color polymer clay over the bird. Add a pair of heat-resistant glossy beads as the eyes and a piece of yellow polymer clay as the beak.

3 Brush some blue chalk powder on its head and body to create a gradient effect.

4 Add a blue polymer clay piece as the tail.

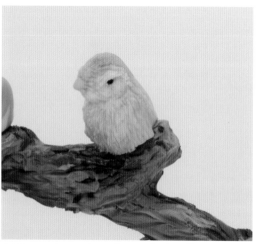

5 Score and scrape to produce the feather effect.

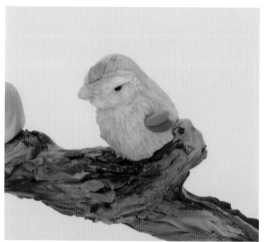

6 Add a pair of blue polymer clay pieces as the wings. Again, create the feather effect.

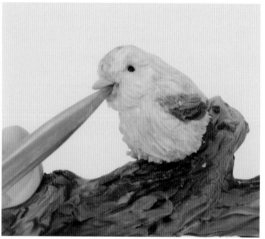

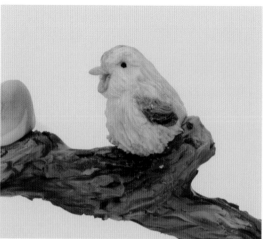

7 Use a stick to push the beak to make a smiling expression. Bird 4 is done.

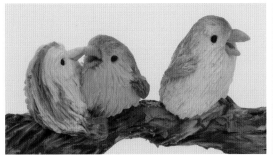
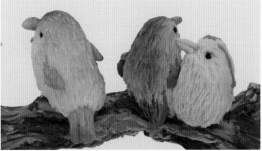

8 Repeat the same steps to decorate birds 1, 2 and 3. Bird 1 has a blue body and tail with a yellow belly and beak. Bird 2 has a light green body, green tail and wings with an orange beak. Bird 3 has a yellow body with an orange beak and wings. The left picture is the front view whereas the right picture is the back view.

Double-Happiness and Table Number

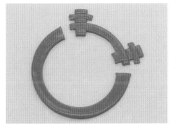

1 Next is to make the word "double-happiness." Roll the red polymer clay into a round piece.

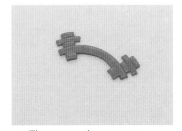

2 Use a circular cutter to cut out a perfect ring. Add 2 short and 1 long pieces as shown. Note that the added pieces are to be parallel and perpendicular to the ring to reflect the beauty of Chinese characters.

3 Add a shorter and wider piece onto the inner side of the segment at each end.

4 Then cut out the segment as shown.

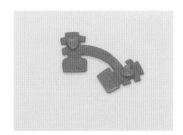

5 Place a bigger rectangular and heart pieces at each end.

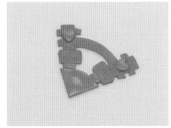

6 Add a pair of shorter pieces below the rectangular pieces produced at step 5. Attach a fan-shaped piece at the bottom. Note that the word "double-happiness" is symmetrical and formed in the shape of a heart.

7 Cut a small slot out of the fan-shaped piece and trim the bottom to form an arc.

8 Use the small heart cutter to cut out from the big rectangular and fan-shaped pieces. Press the heart cutter lightly on the top heart pieces to engrave the smaller hearts inside. "Double-happiness" is set.

9 Make a number 4 with the light green polymer clay. Score some horizontal lines as shown in the picture. Then bake it in the oven.

10 Place the baked number 4 on the top center of the "double-happiness." Apply a layer of gold glitters on the "double-happiness" with your fingers. Then bake it in the oven.

Rocks

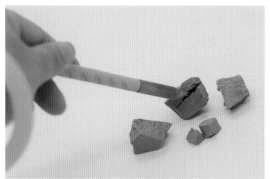

1 Next is to make the rocks below the circle. This process is different from the usual steps which we use a rolling pin or pasta machine to increase the plasticity. Here, we use some silver polymer clay pieces that have been exposed in the air for a while. Slit them with your fingers or an exacto blade and you can see that the texture is very similar to the natural rocks.

Assembling

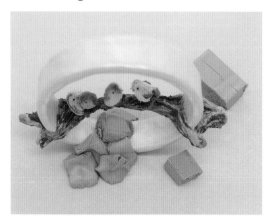

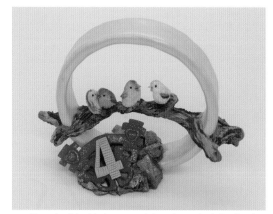

1 Attach them randomly on the bottom of the circle to strengthen the foundation.

2 Place the "double-happiness" directly on the left side of the rock. It can be easily fixed since the rock has not been baked and hardened. Apply a layer of pearl mica powder on the rock to mimic the glossy appearance of rock being washed by the waves. Brush the black mica powder on the cracks to enhance the three-dimensional effect. Last, apply the lawn green and dark green polymer clay on the gaps of the rocks as the moss to generate a scene of the nature and vitality. Then bake it in the oven to complete.